QUEEN ELIZABETH II A BIRTHDAY SOUVENIR ALBUM

QUEEN ELIZABETH II A BIRTHDAY SOUVENIR ALBUM

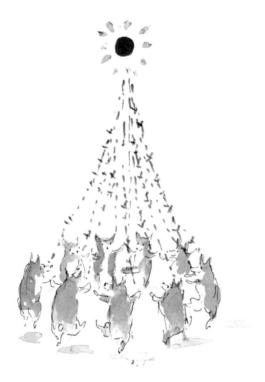

ROYAL COLLECTION PUBLICATIONS

Published by Royal Collection Enterprises Ltd St James's Palace, London SW1A 1JR

For a complete catalogue of current publications, please write to the address above, or visit our website on www.royalcollection.org.uk

© 2006 Royal Collection Enterprises Ltd Text by Jane Roberts and reproductions of all items in the Royal Collection © 2006 HM Queen Elizabeth II

148650

All rights reserved. Except as permitted under current legislation, no part of this work may be photocopied, stored in a retrieval system, published, performed in public, adapted, broadcast, transmitted recorded or reproduced in any form or by any means, without the prior permission of the copyright owner.

ISBN 1 902163 77 X 978 1 902163 77 2

British Library Cataloguing in Publication Data: A catalogue record for this book is available from the British Library

Designed by Peter Drew of Phrogg Design Typeset in Garamond Printed and bound by Studio Fasoli, Verona Printed on Symbol Tatami White, Fedrigoni Cartiere Spa, Verona Production by Debbie Wayment

Endpapers: Graham Rust, *Design for a bookplate for The Queen*, 1986 (pen and ink and wash; RCIN 452736)

Title page: Sir Hugh Casson, *Corgi maypole* (watercolour and pen and ink. Royal Collection)

Right: The Duke of York (later King George VI), Princess Elizabeth of York with umbrella, 1928 (RCIN 2999820)

Opposite: Extract from the Court Circular, 21 April 1926 (Royal Archives)

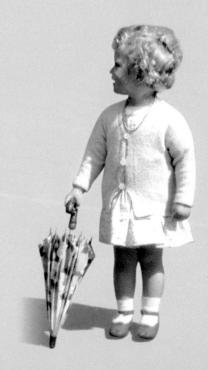

Court Circular.

WINDSOR CASTLE, AFRIL 21. The King and Queen have received with great pleasure the news that the Duchess of York gave birth to a daughter this morning.

The Crown Princess of Sweden, Princess Andrew of Greece, and the Dowager Marchioness of Milford Haven visited Their Majesties and remained to Luncheon.

The King and Queen, attended by Major Reginald Seymour, drove to London this afternoon and visited the Duke and Duchess of York at their residence in Bruton-street, and the Princess Victoria at Marlborough House.

The Right Hon. Sir Austen Chamberlain, M.P. (Secretary of State for Foreign Affairs), and Lady Chamberlain have arrived at the Castle, and the Earl ⁻¹ Countess of Reading and Sir Arthr have left.

The Right Ho-

Her Majesty Queen Elizabeth II was born on 21 April 1926 at No. 17 Bruton Street, the London home of her maternal grandparents, the Earl and Countess of Strathmore.

She was the first child of the Duke of York (known to his family as 'Bertie'), King George V's second son, and his wife, formerly Lady Elizabeth Bowes Lyon.

Bertie 1926

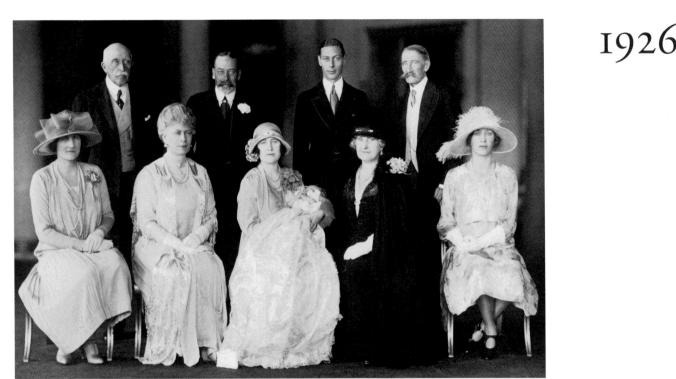

The first photographs of Princess Elizabeth were taken in May, shortly before her christening at Buckingham Palace. The christening group shows the infant Princess in her mother's arms, with her father standing behind (second from right). Her maternal grandmother, the Countess of Strathmore, is seated to right of centre. Princess Elizabeth's godparents were her paternal grandparents, King George V and Queen Mary (both second from left); her maternal grandfather, the Earl of Strathmore (back right); her aunts Princess Mary, Viscountess Lascelles (front right), and Lady Elphinstone (front left); and her great-great uncle, the Duke of Connaught (back left).

The Duke of Connaught's christening present to his great-great niece was this magnificent silver cup.

During much of the six-month overseas tour carried out by the Duke and Duchess of York in the first half of 1927, Princess Elizabeth was looked after by her grandparents, spending time at both Buckingham Palace and the Strathmores' Hertfordshire home, St Paul's Walden Bury.

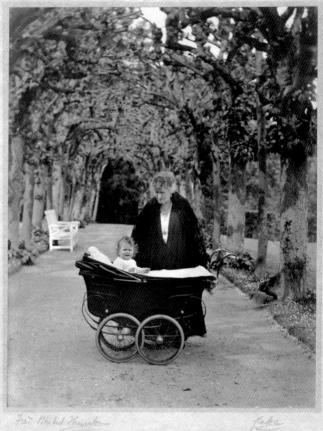

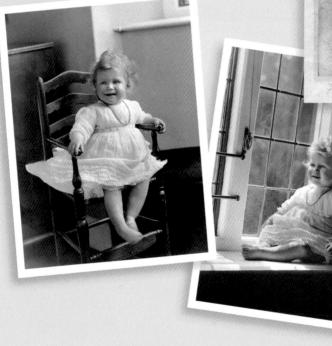

The photograph above of the smiling Princess in her pram was among those sent to the Duchess of York by Lady Strathmore, to record the baby's progress. The Queen has been photographed by passers-by, and by professional photographers, throughout her long life. The fleeting record of her pushing her dolls' pram in Piccadilly contrasts with the relative formality of Marcus Adams's charming record of the Princess with her mother, the Duchess of York, in July 1928.

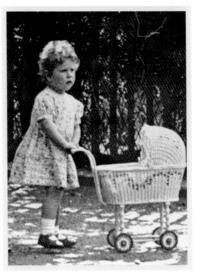

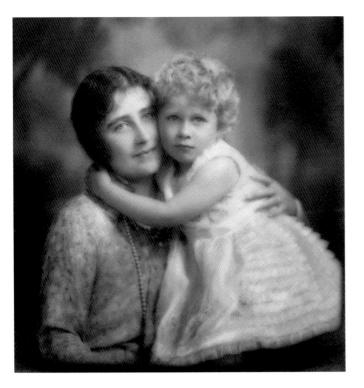

This is one of Princess Elizabeth's dolls.

1928

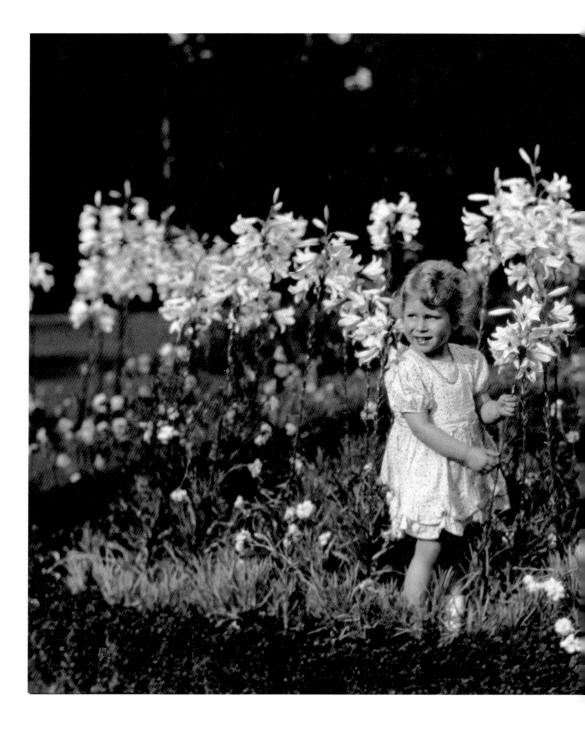

Princess Elizabeth's father was a keen amateur photographer, and his snapshots of his infant daughter speak fondly of his regard for her. This photograph was taken at St Paul's Walden Bury, the Hertfordshire home of the Earl and Countess of Strathmore. It was exhibited by the future King at the 1930 Kodak exhibition.

Queen Mary greatly enjoyed the company of her eldest granddaughter, who accompanied her to the Naval and Military Tournament in May 1930.

The first London home of the Duke and Duchess of York, and of Princess Elizabeth, was No. 145 Piccadilly, destroyed during the Second World War. The tiny Princess is here shown in a horse-drawn landau outside the front door.

HER MAJESTY THE QUEEN.

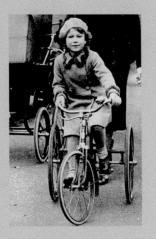

In 1931 the Princess wrote her first letter to Queen Mary, by which time she was confidently riding her tricycle in the park.

145 PICCADILLY

DARLING GRANNY.

THANK YOU VERY

VERY MUCH FOR

THE LOVELY DOLL'S

HOUSE. | DO LOVE

IT, AND I HAVE

UNPACKED THE

The family spent part of the summer of 1931 at Glamis, the Strathmores' Scottish seat. The poise of the 5-year-old Princess is clear from her conversation with the Dowager Countess of Airlie, who was her senior by sixty years.

The second DINING ROOM AND THE HALL. LOVE FROM LILIBET. XXX

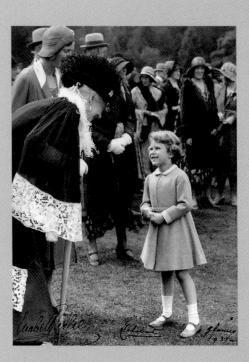

1931

The day nursery at St Paul's Walden Bury contained a much-loved rocking horse. Here Princess Elizabeth shares a ride with her younger sister, Princess Margaret, born in 1930. Their mother had played with the same rocking horse as a child.

Princess Elizabeth enjoyed riding from an early age and was given her first pony when she was 4 years old. By 1932 she was riding on her own.

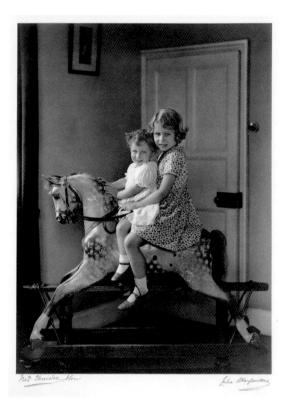

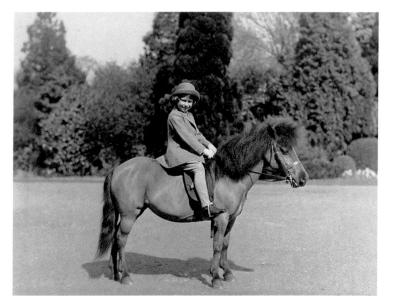

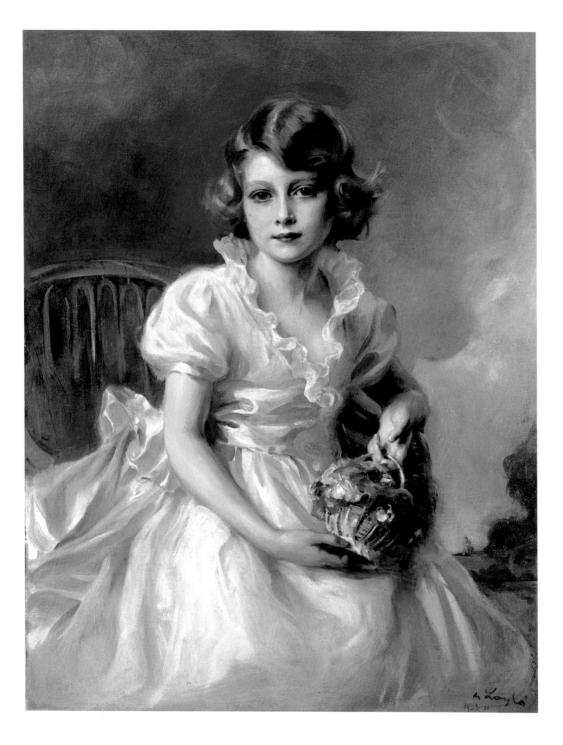

The oil painting of Princess Elizabeth on the previous page was commissioned by her father, the Duke of York, as a gift for her mother. It was painted in 1933 by the Hungarian artist Philip de László. Sittings took place at Royal Lodge, the country home of the Duke and Duchess of York in Windsor Great Park. In the right background is the diminutive figure of the Copper Horse, which could be seen through the window. The photograph on this page was taken by Princess Victoria, King George V's sister, outside the little Welsh Cottage – Y Bwthyn Bach – in the grounds of Royal Lodge. The cottage had been given to Princess Elizabeth by the people of Wales for her sixth birthday in 1932. The Princess stands alongside her grandparents (the King and Queen), with her mother and little sister to the left.

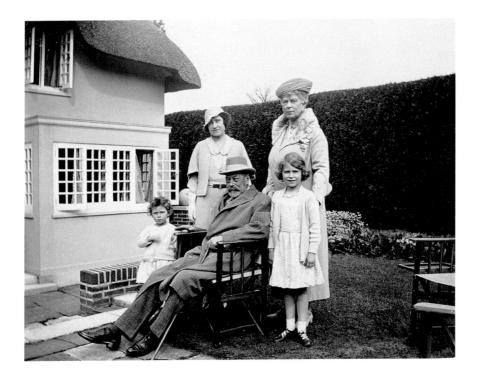

Dear Granny, Thank you very much for the lovely little jury. We loved staying at Sandringham with you. I lost a top front tooth yesterday mooning.

Itaryaut and 5 vent to a laney dress harty at Eady Istois. It was simply lovely. There was a clown and a jester and a snowman and lots of people I knew. There were stalls full of lovely things in them There were lovely flowers and toys and sweets. Eole from Silibet

In another letter to Queen Mary, of February 1934, Princess Elizabeth mentions that she has lost a top front tooth. At the end of the same year she was one of the bridesmaids at the wedding of her father's younger brother, the Duke of Kent, where this portrait photograph was taken.

1934

In spite of the four years that separated them, there was a close bond between Princesses Elizabeth and Margaret. They were photographed shopping together (with their mother and grandmother) in Forfar, close to Glamis, in August 1935.

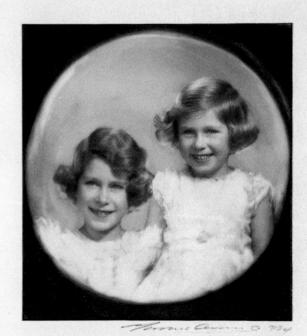

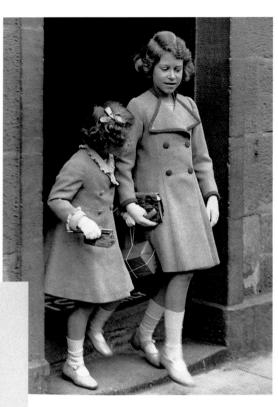

Later that year, the Princesses sent a joint Christmas card – with their names added by 'Lilibet', the elder of the two.

Filibet. 1935 Mangaret

The Hungarian artist Sigismund de Stróbl was professor of sculpture at the Budapest Royal Academy before moving to London. His marble head, completed in 1937, was based on the portrait modelled during visits by Princess Elizabeth to his London studio.

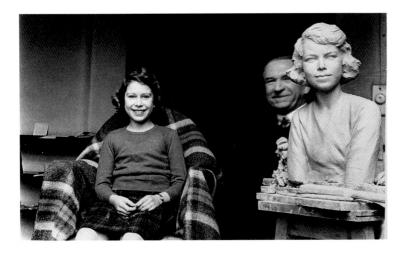

Dogs have always played an important part in the lives of The Queen and her family. Here Princess Elizabeth holds Jane, the second royal corgi to have been acquired by the Duke and Duchess of York. The first one – Dookie – was purchased in 1933.

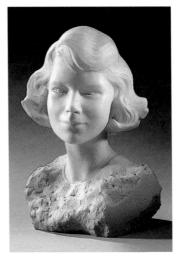

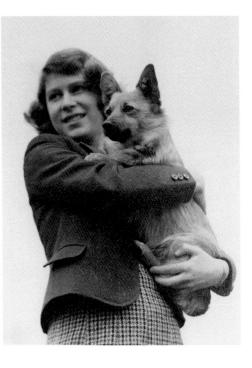

1937

The	Coton			
		12世	May	1937.
To.	Mummy	and	Papa	
. 1	Ln Hemo	Py of	Their	Coronat
	F	rom Lil	bet	
		0	y Her	nself.

An Account of the Commation. At & o'clock in the morning I was woken up by the band of the Royal Marine winking up just outerde my window I leapt ent of bid and so aid Bibs. We put on dressing. gowns and whoes and Bobo made me put on an idendown as it was so cold and we enough in the window looking onto a cold, minty m Shere were already some people in the 1-There was arready some people was a some and all the time people was conneg to them in a stream with according preserve in themese. Every now and then we topping in and out of led looking at the bands and the soldiers At mix o' clock Bobs got up and instead of getting up at my usual time I sumped out of ted at helf pair area. When I use going to the bathroom i pressed the lift as usual, and who should walk out but Miss Daly 'I was very pleased to see her. When I was dressed I wend into the survey and Morgaret Stahinstone, who

came to breakfast, was waiting there. We did not eat very much as us were too weited. After we had prinisted we looked out of the window until it was time to get dressed. We saw the Canadia mounted Police in their red wats and once when a policimon wont by on his bright, morgbody chured!

When we were dressed as showed our . selves to the inition and the homerinaids. This I whall try and give you a description of our dresses

Hy were white with with old eream have not had little gold have all the way down the middle. They had proffeed slaves with one little bow in the centre. Then there were the roles of prosple velocit with gold on the edge. We next along to Mumming's

bedroom and we found her putting on her dress. Popp was dressed in a white whirt, breeches and stochings, and over this he were a crimeres ratio Then a prage came and said it was him wat.

to go down, so we Jussed Manny, and wished her good luck and vent down. There we snich produce to Aunt Blice, Aunt Marina and Aunt Mary with whom i were to drive to the Abbey. We were then told to get into the carriage. When we got in we still had to wait a few minutes and then our carriage moved from the door. At forst it was very jully but we soon got used to it. We went round the memorial, down the Mall, through Admiralty Arch along Whitehalt passe the Constant and the Horse General' Parade, and then Westminster Alley. When we got out we were welcomed by the Duke of Nortolk, the Exart Marshal.

norm until it was time to go up the siste. This we arranged ourselves to form the procession, First of all came two Hendles, then two Gentleman Ushers, then all in a line, Mongaret, Aunt many and myself. When we got to the Theatre we sat down and waited for green

4

Mary's procession. Grannic looked too bean tiful in a gold dress pratterned with golden flowers. Then we went up the steps and white There we sat down and waited for i have stayed in her mind for ever. about half- an - hour until Mumory 's procession legan. Then came Papa looking very beau tiful mi a crimson robe and the Cap of State. Then the service began.

" thought it all very, very wonderful and I expect the Abby diel, too. The arches and became at the top were covered with a sort of have of wonder as Dana was crowned, at least I thought so.

all the preverses post on their corrorets it looked wonderful to see arms and coronets hovening in the air and then the arme disappear as it by magic. Also the music was lovely and the band, the orchestra and the new organ all played brantifully.

5

What struck me as being rather old was that for annie did not remember much of her own Coronation I should have thought that it wo

At the end the service got rather boring as it was all progens. Grannic and I were booking to see how many more pages to the end, and we turned one more and then I pointed to the word at the bottom of the prage and it said "" "inis" We both miched at each other and twined back to the service

After Papa had prassed we were all orlivering because there was a most auful & draught coming from nomewhere, so we were glad to get out of the box. This we went down the airle, first a gentleman I did not Jenow, then Margaret and myself and then Grannie. When we got back to our dressing room we had some sandwiches, stubbed rolls, orangeade and lemonade; Then we left for on

long drive,

On leaving the Abbey we went along the Embandment, Rorthumberland Avenue, through Irafalgar, St. Jamis's St., Recardilly Regent St. Oxford St. with Selfridge's lovely figures, through Marble Arch, through Hyde Prark, Hyde Bark Corner, Constitution Hill, round the Memorial and into the courty and. Then we went up to the corridor to see Then use ween up to the corrector to see the Crack coming in Then Munning and Papo came up and raid "fordnorming" and were congratulated. Then we all want on to the Binkong where millions of people were waiting Julow. After that we all want to be protographed b in front of those awful lights. When we not down to tes it was nearly six o'clock! When I got into bed my lege ached twinkly. As my head touched the pillow I was askep and I did not write up till nearly eight o'clock the next morning.

The death of King George V in January 1936, followed by the abdication of King Edward VIII in December of the same year, led to the accession of the Duke of York as King George VI. He was crowned at Westminster Abbey on 12 May 1937 - the date previously fixed for King Edward VIII's coronation. Princess Elizabeth, now heir to the British throne, wrote a full account of the ceremony in a lined exercise book, concluding that it was 'very, very wonderful'. After the service the Princesses were photographed with their parents in the Throne Room at Buckingham Palace, wearing the gold coronets made for the occasion.

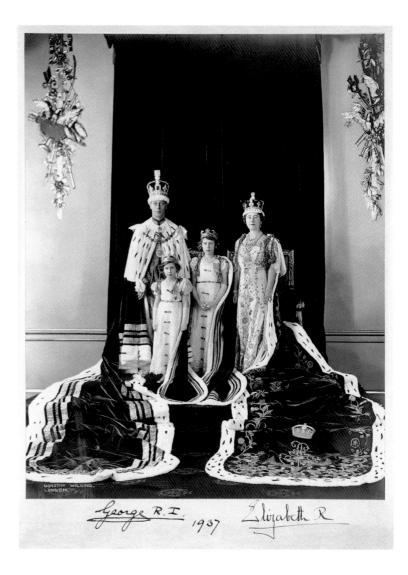

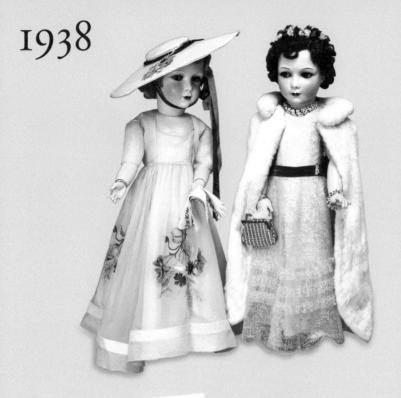

BUCKINGHAM P

15 th Nov. 1938.

Darling Gramie, Shank you very much for the lovely brooch-How clever that lady must be to make it out of a penny. It is very like Grandpapa. What a horable day for driving in a carriage and it must be very foggy in the

Channel. M. Corlin came yesterday hand over the dolls on alf of the French people and we showed all their lothes. Thank you very much again your lowing granddaughter Lilibet

'France' and 'Marianne' were made in France for Princess Elizabeth and Princess Margaret in 1938. With their magnificent wardrobes, supplied by Parisian houses such as Lanvin, Worth, Hermès and Cartier, they were presented by Charles Corbin, French Ambassador in London, as described in a letter to Queen Mary. A temporary public display of the dolls (which were clearly not to be played with) was soon arranged at St James's Palace, in aid of the newly renamed Princess Elizabeth of York Hospital for Children. The dolls are now on view at Windsor Castle.

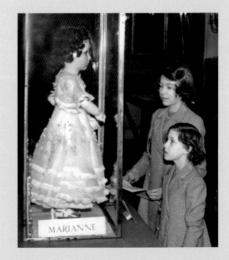

BUCKINGHAM PALACE

Darling Grammins Jan very roomy to Sean that you have a some throat. I do dope it will not develope into influenza. Shet would be a great bore during this cold spell of weather. We had one of the coldest weatends we have had thes winter at Royal dodge this time. It was indy we have begin riding in the indig - school here and we are deriving to give which is great for

Surpret we will be receiver y at Windson soon, it does some norm so quickly and to think I am already going to be theiten I do hope you will get better very quickly and he able to go about a yain. Your very loving grand- daughter, Liliket The diligent and affectionate correspondence with Queen Mary continued with this letter in which the Princess looks forward to seeing her grandmother at Windsor, adding 'to think I am already going to be thirteen'. 1939

Princess Elizabeth's thirteenth birthday was spent at Royal Lodge in Windsor Great Park and was marked by a charming photograph of the King riding with his two daughters. The saddle used by Princess Elizabeth at this time has remained at Windsor.

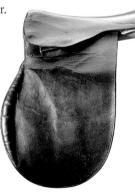

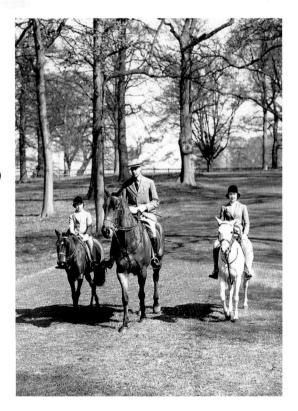

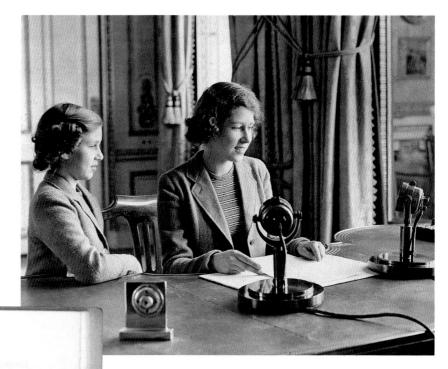

A Message from Princess Elizabeth to British Children Abroad

IN WISHING YOU ALL GOOD EVEN ing, I feel that I am speaking to friends and companions who have shared with my sister and myself many a happy children's hour. Thousands of you in this country have had to leave your homes and be separated from your fathers and mothers. My sister Margaret Rose and I feel so much for you, as we On 12 October 1940, just over a year after the outbreak of war, the 14-year-old Princess Elizabeth made her first radio broadcast, to the children of Britain and the Empire, as part of the BBC's Children's Hour programme. A miniature printed transcript of the broadcast text was subsequently published in New York, and a specially bound version was presented to the King and Queen.

I94I

This photograph of the Princesses working on their vegetable plot at Royal Lodge, with corgi in attendance, shows something of the relatively carefree life which they were able to enjoy away from London. While the King and Queen remained at Buckingham Palace during the week, the Princesses spent much of the war years at Windsor. The platinum and diamond basket brooch, set with rubies, Indian emeralds and sapphires, was given to Princess Elizabeth by her parents in 1941.

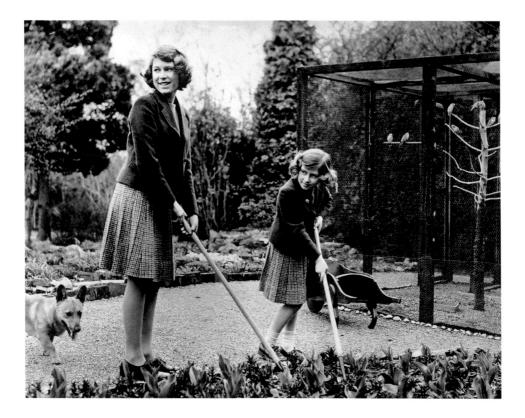

Like all British subjects, Princess Elizabeth's life was subject to wartime legislation. She was required to carry an identity card at all times, and to use ration books to obtain food and clothing.

The Princess – wearing her Girl Guide uniform – was photographed on 5 May 1942 registering at a labour exchange. Her ration books and identity card have survived in the Royal Archives.

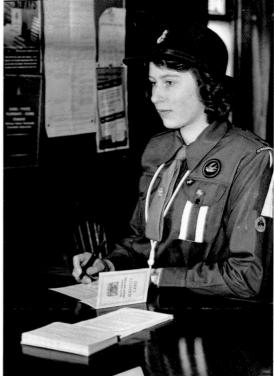

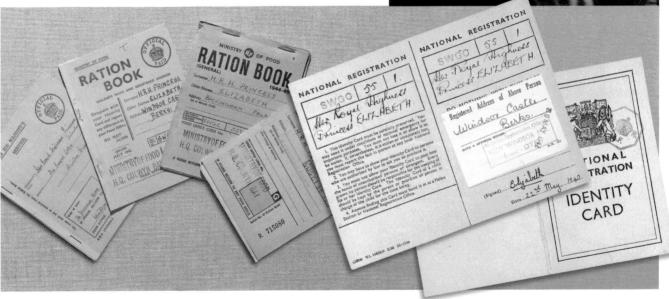

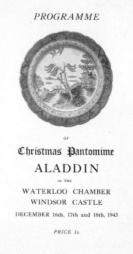

ALADDIN

Aladdin .			PRINCESS ELIZABETH
Princess Ros	ana		PRINCESS MARGARET
Widow Twa	ikey		Cyril Woods
Abanazar .			JAMES COX
Sing Lo .			MAUREEN SHORLE
Sing 1fi .			RENE HELPS
Ping Ho .			KENNETII RICHARDSON
Pong Ho .			GRORGE PRATLEY
Strolling Pla	yer		CORPORAL BOARMAN (The Life Guards)

OR HESTRA OF THE ROYAL HORSE GUARDS ("THE BLUDS") (under the direction of Captain J. A. Thornburrow)

Written and produced by H. I. Tanker

Scenery by J. M. Merrylecs

Act I Scene : A Street in Peking

Act 1 Scene z : The Teashop of the Willow Pattern Plate

> Act II Scene 1 Widow Twankey's Laundry

> > Act III Scene : The Ruby Cave

Act III Scene 2 : The Emperor's Palace

1943

Aladdin was the Christmas entertainment at Windsor in 1943. Princesses Elizabeth and Margaret headed the cast, and appear in the group photograph at either side of the Headmaster of the Royal School at Windsor, who wrote and produced the pantomime. This was one of many pantomimes staged in the Waterloo Chamber during the war years. Tickets were sold in aid of the Wool Fund – which supplied knitting wool for the making of comforters for members of the armed forces.

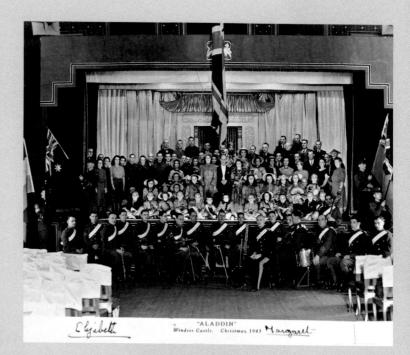

On her eighteenth birthday Princess Elizabeth was presented with the Colonel's Colour of the Grenadier Guards in the Quadrangle at Windsor Castle. She had been appointed Colonel of the regiment two years before, on her sixteenth birthday. In 1952, when The Queen became Colonel-in-Chief of all the Household regiments, this Colour was placed in the Queen's Guard Chamber, where it remains on view to this day.

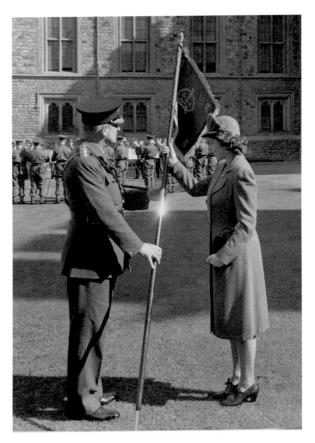

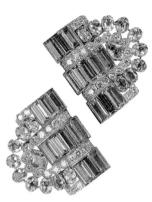

These aquamarine clips by Boucheron, and linked bracelet by Cartier, were among Princess Elizabeth's eighteenth birthday presents. Both were gifts from the King and Queen.

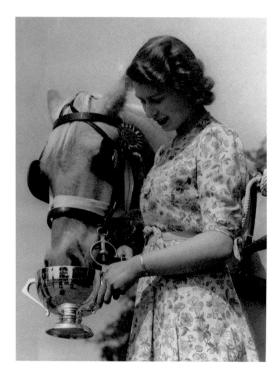

The first Royal Windsor Horse Show took place in 1944. Princess Elizabeth won this silver cup for 'The best turn out not exceeding 13 hands' in the Private Driving class.

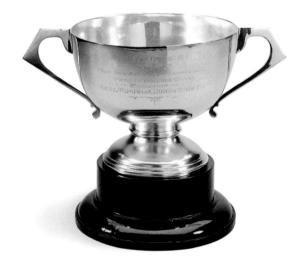

1944

TRABETH

HR H. PRINCES

Princess Elizat Territorial Ser when she was Second Subalt Windsor. Afte vehicle mainte she qualified o pineteenth bir

Princess Elizabeth joined the Auxiliary Territorial Service (the ATS) early in 1945, when she was registered as No. 230873 Second Subaltern Elizabeth Alexandra Mary Windsor. After undertaking a driving and vehicle maintenance course at Aldershot, she qualified on 14 April, just before her nineteenth birthday. Three months later she was promoted to Junior Commander. After the declaration of peace in May 1945, Princess Elizabeth was able to travel more widely and undertook a broader range of duties. In March 1946 she launched the new aircraft carrier HMS *Eagle* at the Harland & Wolff shipyard in Belfast. Five months later she was invested as a bard, with the title 'Elizabeth o Windsor', at the annual National Eisteddfod of Wales.

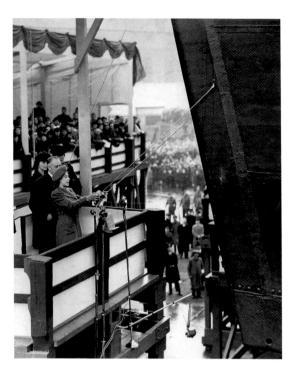

1946

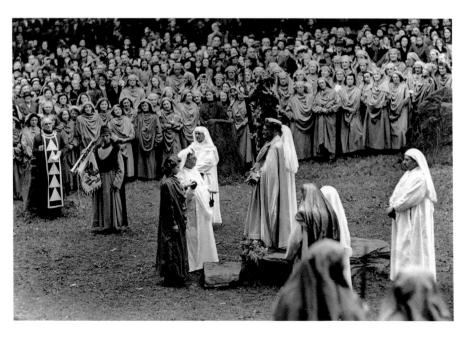

In February 1947 Princess Elizabeth joined the King and Queen and Princess Margaret for the royal tour of South Africa. They travelled out on HMS *Vanguard*, where the ship's cat clearly enjoyed the Princesses' company. In South Africa the longer journeys were undertaken on the Royal Train. A press photographer captured the Princess's delight at sounding the train's whistle. While the Royal Family was in South Africa, Princess Elizabeth celebrated her twenty-first birthday. The Government of South Africa presented her with a necklace made of twenty-one magnificent diamonds. After the accession the necklace was shortened and the diamonds which had been removed were made into a bracelet.

IS THE CROWN but something set above The jangle and the jargon and the hate) the Coming MARRIAGE of HER ROVAL HIGHNESS, Of strivers after power in the State, A symbol, like a banner, for mens' love? The PRINCESS EL17ABETH When hope is dim and luck is out of joint, when enemies within, without, assail, where a Grown shines, the courage cannot fail, There a land's spirit finds a vallying-point.

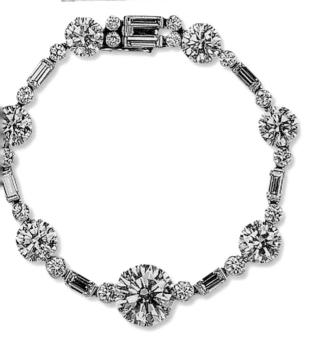

On 10 July 1947 the engagement was announced between Princess Elizabeth and her third cousin, Lieutenant Philip Mountbatten (born Prince Philip of

Greece). The platinum and diamond

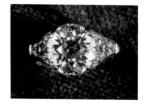

engagement ring was made using stones from a tiara that had belonged to the bridegroom's mother. The engagement was celebrated in a poem by the Poet Laureate, John Masefield.

1947

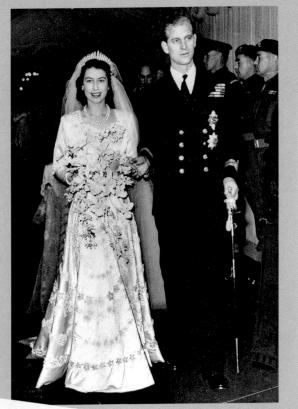

The Lord Steward anded by Their Majesties to invite is commande to a Breakfast at Buckingham Palace en Thursday, 20th November, 1947. after the Ceremony of the Marriage of The Runcess Elizabeth Leutenant Philip Mountbatten, R.N. It is requested that the refly to this invite the Marter of the Household at Buckingh may be addressed to

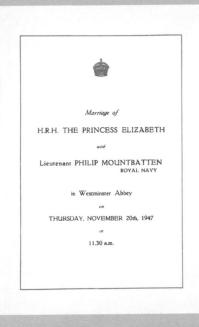

The Princess's wedding took place at Westminster Abbey on 20 November 1947. It provided a moment of joy and celebration amidst the difficult years of national recovery following the end of the war. The bridegroom was created HRH The Duke of Edinburgh shortly before the wedding. Following her marriage, Princess Elizabeth was also known as The Duchess of Edinburgh. Princess Elizabeth's first child, Prince Charles, was born at Buckingham Palace on 14 November 1948. A hand-written announcement of his birth, signed by the royal doctors, was hung on the palace railings.

The Princess Elizabeth, Duchess of Edinburgh Was Safely delivered of a Prince at nine fourteen pm today. Her Royal Highness and her son are both doing well.

Williatt h.S. F.RC.0.5 Then I Pede Ares Arcos "YHALL PFARAS D.A.

The King and Queen gave their daughter this flower basket brooch to celebrate the new arrival. Princess Elizabeth is shown wearing the brooch in the first photographs of mother and child, taken by Cecil Beaton in mid-December.

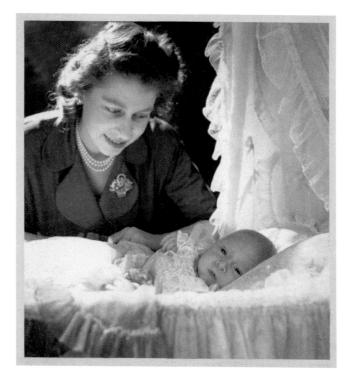

1948

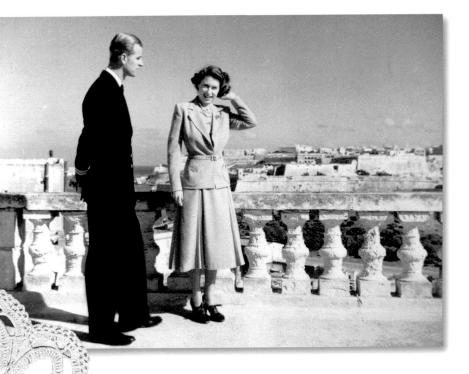

The Duke of Edinburgh resumed his naval career after his marriage. In October 1949 he was appointed second-in-command of HMS *Chequers*, part of the Mediterranean fleet based in Malta. For nearly two years Princess Elizabeth divided her time between Britain and Malta; the royal couple are seen here on the roof of the Villa Guardamangia in Malta. This Maltese lace mat was part of a gift to the Princess from the people of St Vincent de Paule in 1949.

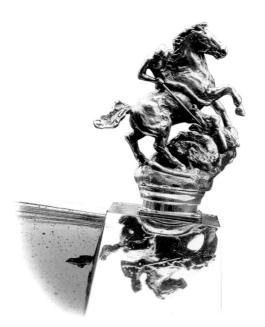

This magnificent Rolls-Royce Phantom IV was made for Princess Elizabeth and The Duke of Edinburgh in the late 1940s. The detachable mascot on the bonnet – a silver figure of St George and the Dragon – was designed by the artist Edward Seago and remains in use to this day on The Queen's official car.

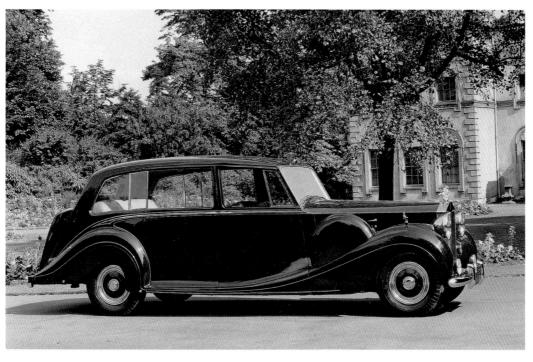

1949

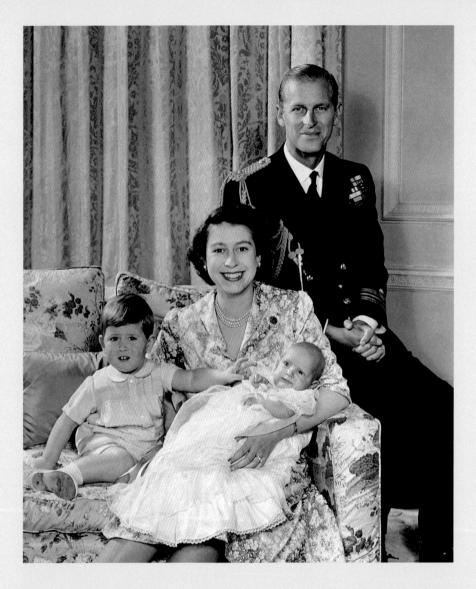

Princess Elizabeth's second child, Princess Anne, was born on 15 August 1950 at Clarence House, into which her family had moved one year before. In the month before Princess Anne's birth The Duke of Edinburgh had been promoted to the rank of Lieutenant-Commander.

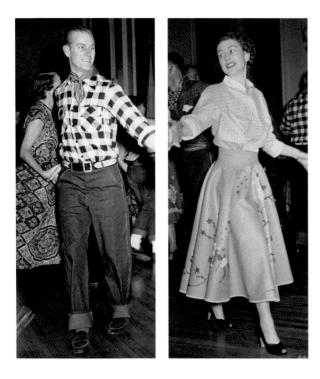

In October 1951 The Duke of Edinburgh and Princess Elizabeth embarked on their first major tour together, to Canada and the United States. On the last evening of their stay in Ottawa, the Governor-General gave a private party in their honour, during which they took part in a Canadian square dance. This elegant dress was made for one of Princess Elizabeth's official appearances c.1950.

1951

Just two months after their return from North America, the royal couple set off on a Commonwealth tour which was due to take them to Australia and New Zealand, via East Africa and Sri Lanka. News of The King's death on 6 February 1952 reached the royal party at Sagana Lodge, Kenya. The tour was immediately cancelled and on 7 February the new Queen was greeted on arrival at London Airport by her Household and Government, including the Prime Minister, Winston Churchill. On the following day she was formally proclaimed Queen.

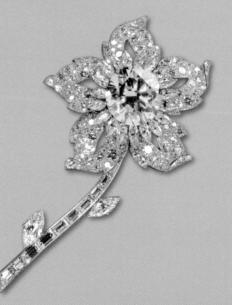

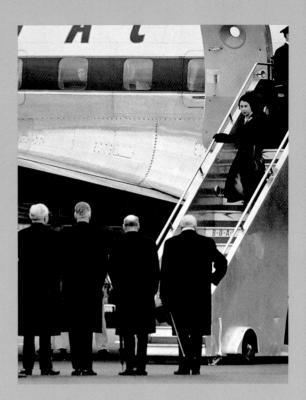

The Williamson diamond brooch was made for The Queen by Cartier in 1952, as a setting for the 54.5-carat pink diamond she had been given by John T. Williamson as a wedding gift in 1947. The diamond had been discovered in Dr Williamson's mine in Tanganyika in the month before the royal wedding. In 1948 it was cut into a 23.6-carat brilliant in London, and was later set into this jonquil-shaped flower.

At the time of The Queen's accession her family's London residence was Clarence House, where they were shown by the artist Edward Halliday. The Queen and her family moved to Buckingham Palace before the Coronation in the following year.

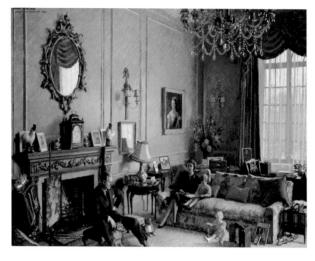

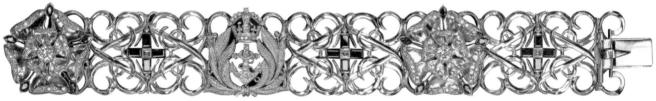

In November 1952 The Queen and Duke of Edinburgh celebrated their fifth wedding anniversary. The Duke's anniversary present was this bracelet, made by Boucheron to The Duke's own design. It includes interlocking Es and Ps, a naval badge set in diamonds, crosses made of rubies and sapphires, and two Roses of York. Christmas 1952 was spent at Sandringham, where The Queen broadcast her first Christmas message. The tradition of the Christmas broadcast had been begun by her grandfather, King George V, exactly twenty years earlier.

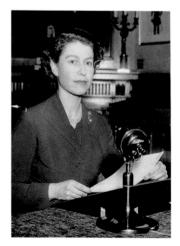

By the start of 1953 preparations for the Coronation, set for 2 June, were well under way. The purple velvet Coronation Robe, embroidered at the Royal School of Needlework, required meticulous handiwork, using a variety of different materials and techniques.

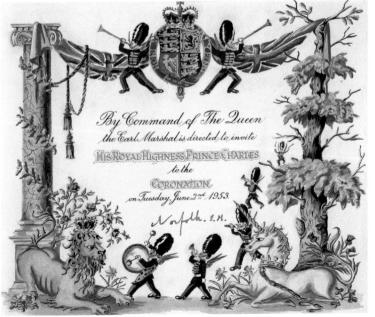

The Queen's son and heir, Prince Charles, received his own special invitation to the Coronation in Westminster Abbey.

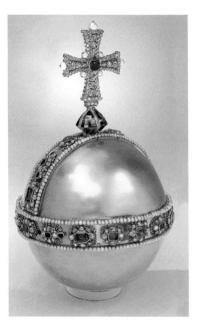

The crowning is the most dramatic moment of the Coronation ceremony. It is a stage in the fourth part of the ceremony – the investiture of the Sovereign with the ornaments that are 'the outward and visible signs of an inward and spiritual grace'. Among these are the Orb, the Sceptre with Cross, and Saint Edward's Crown.

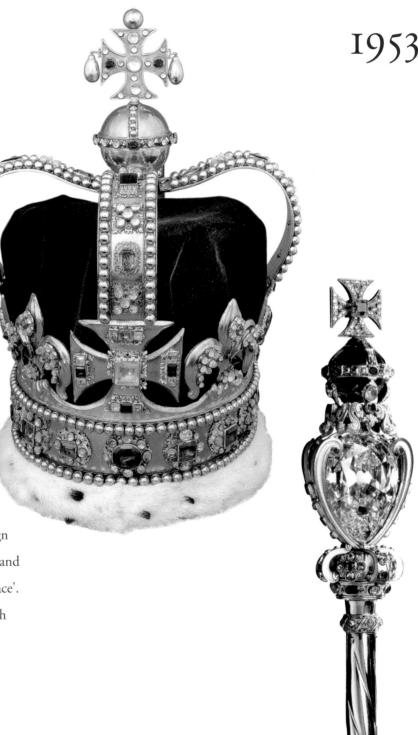

Towards the end of her Coronation Service, The Queen changed into the velvet Coronation Robe and exchanged Saint Edward's Crown for the Imperial State Crown, which she wore for her return to Buckingham Palace (right). The Queen's Coronation was celebrated throughout the nation and Commonwealth. An estimated twenty million people watched the ceremony in their homes, for it was televised for the first time – at The Queen's insistence. In the evening a firework display lit up the Thames at Westminster.

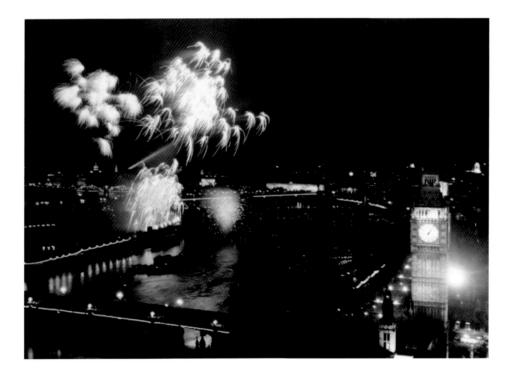

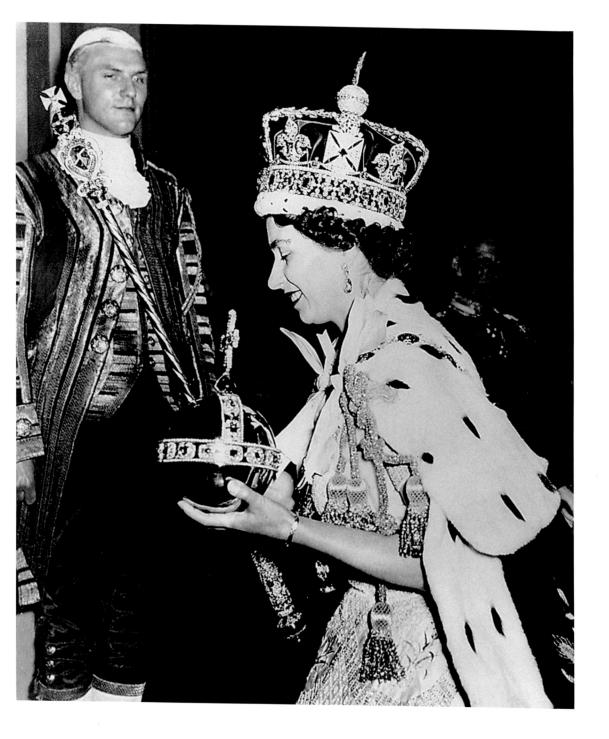

The Queen's longest-ever tour, to Commonwealth countries in the West Indies, Australasia, Asia and Africa, began in November 1953 and lasted until May 1954. The total distance covered was over 40,000 miles. Here The Queen shades herself from the bright Australian sunshine while being driven in an open-topped car en route to Parliament House in Brisbane on 10 March. This gold lamé and white lace one-shoulder gown was designed by Norman Hartnell for the royal tour in 1953-4. Hartnell had also

designed Princess Elizabeth's wedding dress and The Queen's Coronation dress.

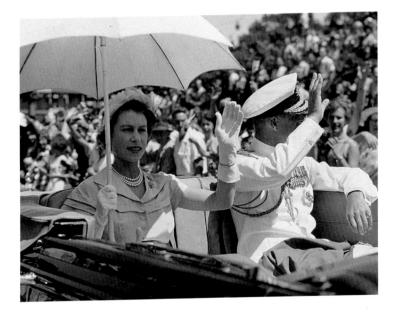

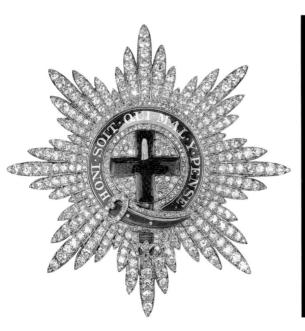

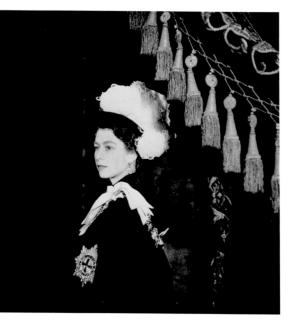

The Order of the Garter, founded in 1348, is the senior British Order of Chivalry. The Queen was appointed a Lady of the Garter by King George VI in 1947, shortly before her wedding. The monarch is Sovereign of the Order and personally appoints new Knights – and Ladies – of the Garter. The Queen was portrayed in her Garter Robes by Cecil Beaton in November 1955. Her diamond-set Garter Star, which had been a present from the Royal Navy to King George VI on his marriage in 1923, was given to Princess Elizabeth by her father at the time of her investiture. The double-sided cameo badge, made for George IV in the 1820s, has the emblem of the Garter on one side (shown here), and the emblem of the Thistle on the other.

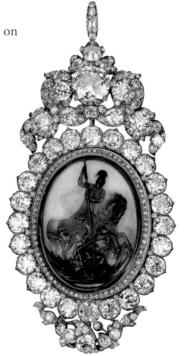

1955

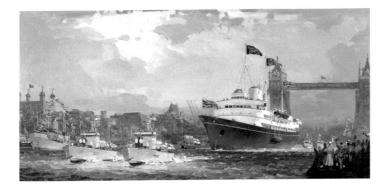

This photograph of the Royal Family on board HMY *Britannia* was taken in 1956. By that time the Royal Yacht had been in active service for over two years. Plans for a new vessel were announced in October 1951 and *Britannia* was launched by The Queen in April 1953. She was commissioned in January 1954 in time to be used for the final homeward journey, from Malta to London, at the end of the 1953–4 Commonwealth tour. Sir Hugh Casson, who had designed the royal apartments on *Britannia*, included the sketch below in a letter to The Queen.

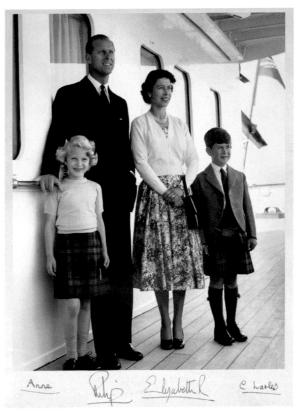

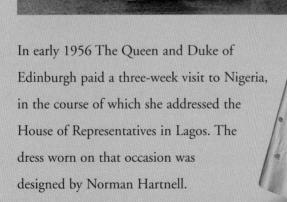

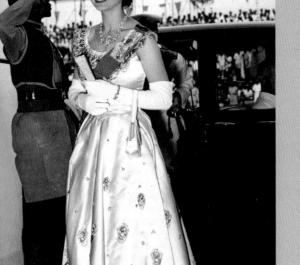

The State Visit to the United States in October 1957 was the fourth such visit undertaken by The Queen in a single year. In New York a traditional ticker-tape welcome was provided for the royal couple.

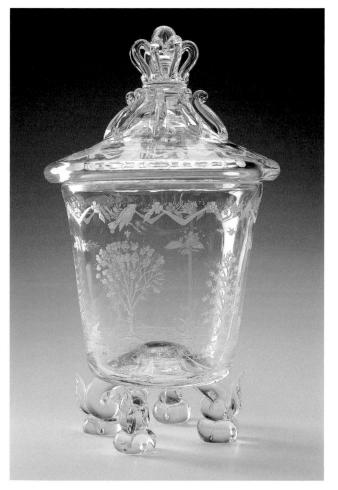

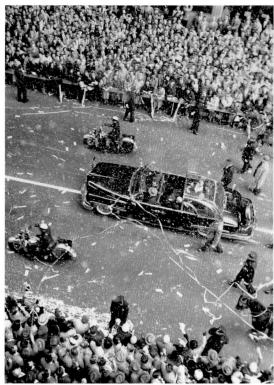

In the course of this visit President Eisenhower presented The Queen with an engraved Steuben glass cup decorated with animals, trees and birds native to North America.

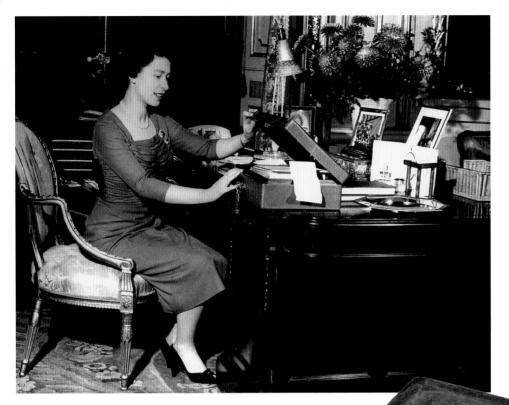

Each day of her life since February 1952, The Queen has dealt with her 'boxes' – the leather-covered cases containing documents and papers for her attention, forwarded by her Private Secretary.

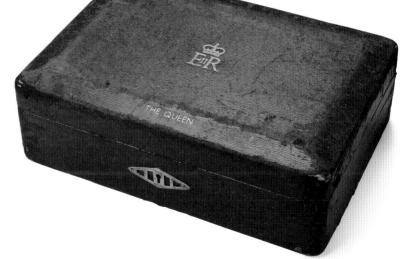

1958

The Queen in the Private Dining Room at Windsor Castle, painted by The Duke of Edinburgh. The Duke began to paint in oils in the late 1940s, and was encouraged and assisted by Edward Seago.

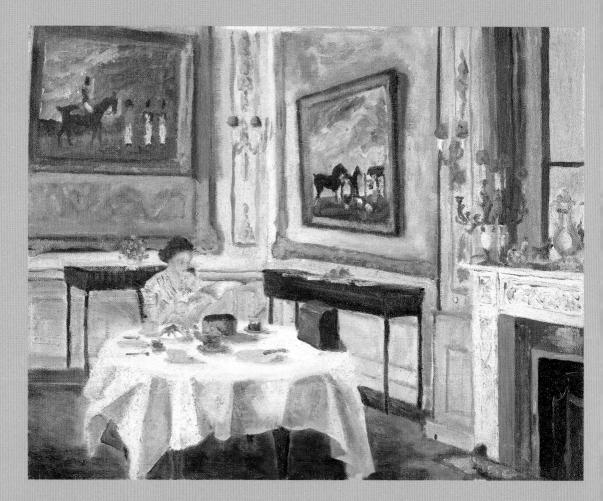

Sugar was a favourite royal companion until her death in 1965 and in 1959 was photographed with The Queen in the grounds of Frogmore House, Windsor.

1959

Sugar was the daughter of The Queen's first corgi, Susan, which she had been given in 1944. This portrait of Sugar, drawn in 1957, hangs in The Queen's Sitting Room at Buckingham Palace.

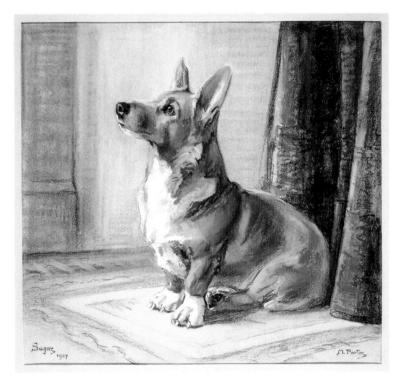

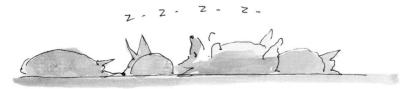

1960

Receiver Say & - Rome cich (an uny spring. Whi wan The godes they los mine prove 2-1/2:13. The storm , chills Park Sp & lightime leaves affer All entrying. low, Priverer, suret 1 con this Our thing his laws wig · Die ayes an any thing Traches what a primerion them of Join For way dues but's for Now a with water's gog mine lall gurler Sfri To your as itid so one to error 1 may in sing Line surbane caroling: The leasts of comments and an . Row met is heffind your You prively take, you The burising from of (A. fini

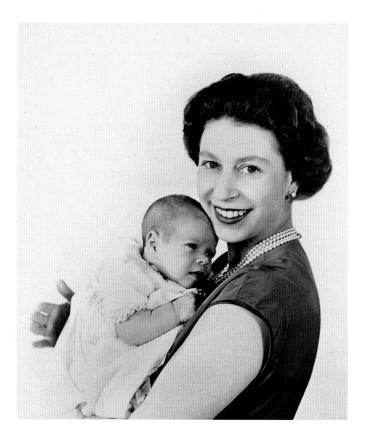

The Queen's second son and third child, Prince Andrew, was born at Buckingham Palace in February 1960. His arrival was celebrated in verse by C. Day-Lewis, who was to become Poet Laureate in 1968, following the death of John Masefield. The 'Birthday Song for a Royal Child' was set to music by Arthur Bliss, Master of The Queen's Music.

In May 1960 Cecil Beaton photographed The Queen dressed for the wedding of Princess Margaret to the photographer Antony Armstrong-Jones (created Earl of Snowdon in 1961). The Queen's dress was another creation of Norman Hartnell. The diamond brooch worn on this occasion is the 'Lover's Knot' which The Queen inherited on Queen Mary's death in 1953.

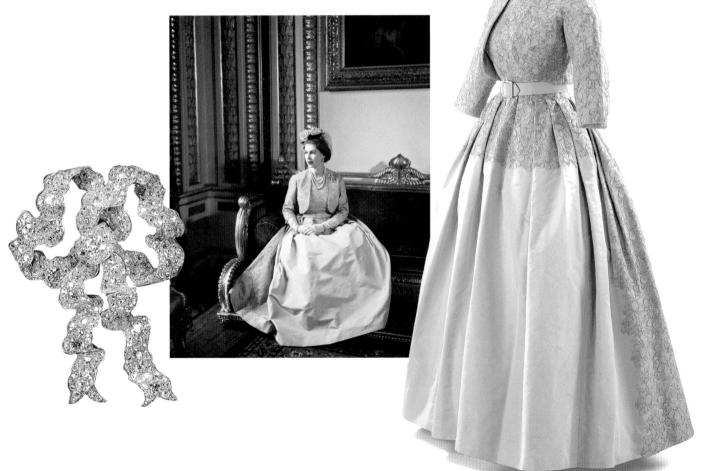

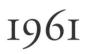

The Queen paid her first visit to the Indian sub-continent in 1961, when she visited India, Pakistan and Nepal. In the course of a six-week tour The Queen was honoured with a ceremonial ride on an ornately decorated elephant.

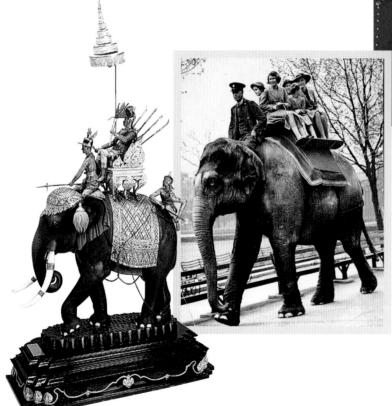

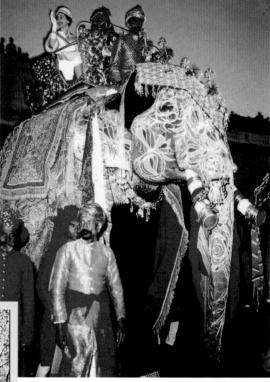

A press photographer in 1939 had caught The Queen enjoying an earlier elephant ride, at London Zoo; while in 1960 the King and Queen of Thailand had presented The Queen with this exotic model of an elephant during their State Visit to the United Kingdom.

The original cathedral (formerly a parish church) in Coventry had been largely destroyed by bombing in November 1940. The competition for a new building, held in 1951, was won by Sir Basil Spence. The Queen laid the foundation stone of the new Coventry Cathedral in 1956 and in May 1962 signed its Sentence of Consecration. The vast tapestry of Christ in Glory, set behind the High Altar, was designed by Graham Sutherland. One of Sutherland's preliminary designs for the tapestry was acquired by The Duke of Edinburgh in July of the same year.

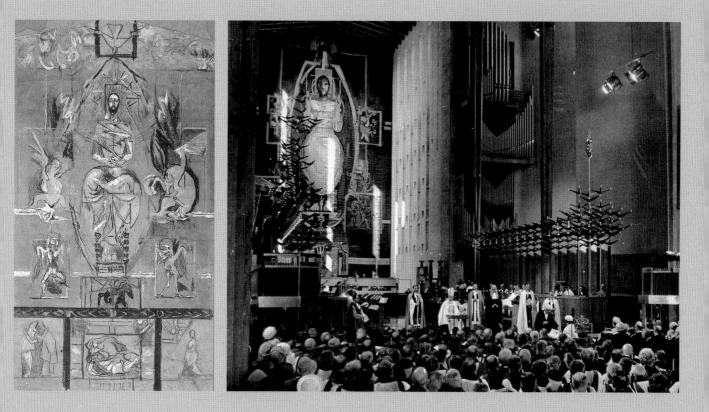

In February–March 1963 The Queen paid her second visit to Australasia. In 1963 she opened the New Zealand Parliament in Wellington, wearing this beautiful ivory silk satin dress.

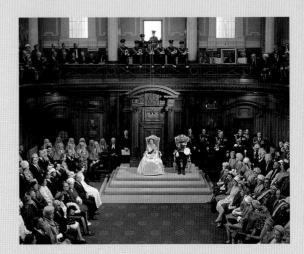

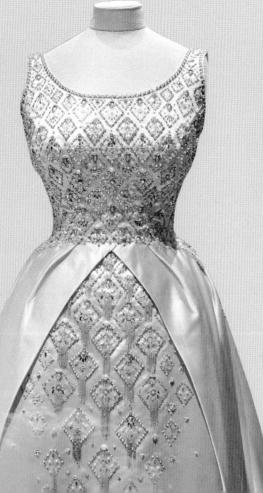

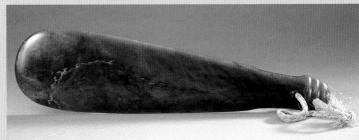

This greenstone mere (or club) was presented to The Queen by the Maori chief Paora Rerepu Te Urupu in 1964, the year after her visit to New Zealand. The Chief's forebears had used the mere to fight Europeans; he hoped that it would now assist in the campaign to bring Europeans and Maoris closer together.

Prince Edward, The Queen's fourth child, was born at Buckingham Palace on 10 March 1964. Later that year the infant Prince was photographed with his mother and Prince Andrew. He was christened in the Private Chapel at Windsor Castle on 2 May. His richly decorated christening cake was crowned with a crib. Prince Edward's first public appearance came after the Trooping the Colour in the following month, when The Queen brought her baby son onto the palace balcony to show him to the crowds.

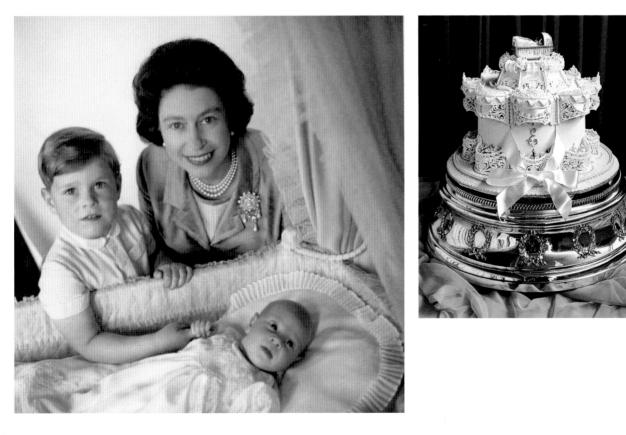

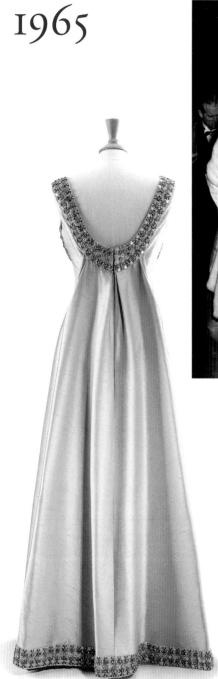

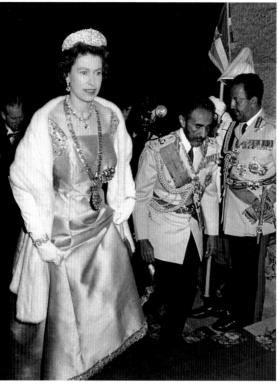

In February 1965 The Queen and The Duke of Edinburgh paid a State Visit to Ethiopia at the invitation of Emperor Haile Selassie, who had himself paid a State Visit to the United Kingdom in October 1954. The Queen's dress of green silk celebrates one of the national colours of Ethiopia and was designed by Norman Hartnell for the State Banquet in Addis Ababa. The silver cross was given to The Queen by the Emperor in 1969.

The final of the 1966 World Cup was played at Wembley Stadium on 30 July. The Queen was clearly delighted to present the cup to Bobby Moore, the captain of the England team. The Queen's programme for this famous match was given a gilded leather cover, in keeping with the importance of the occasion.

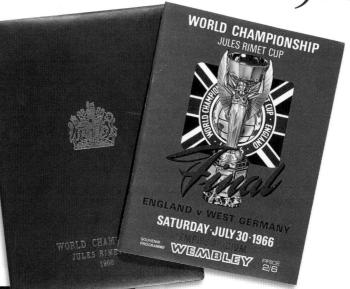

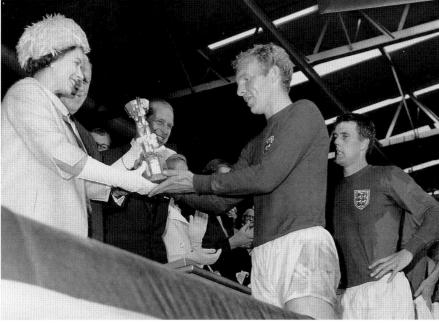

Every year, usually in late October or early November, the Sovereign drives in state to the Palace of Westminster for the State Opening of Parliament. Each new session of Parliament opens with The Queen's Speech, delivered to the members of both Houses in the House of Lords. For the ceremony itself she wears the Imperial State Crown.

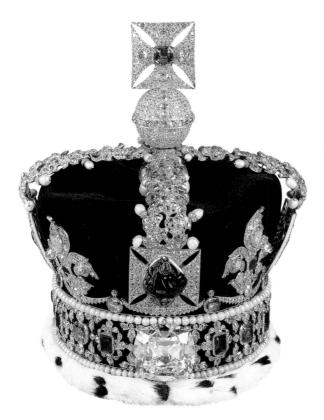

For the journeys between Buckingham Palace and the Palace of Westminster for the State Opening of Parliament, The Queen wears the magnificent Diamond Diadem, originally made for George IV in 1820.

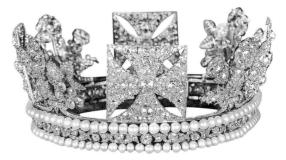

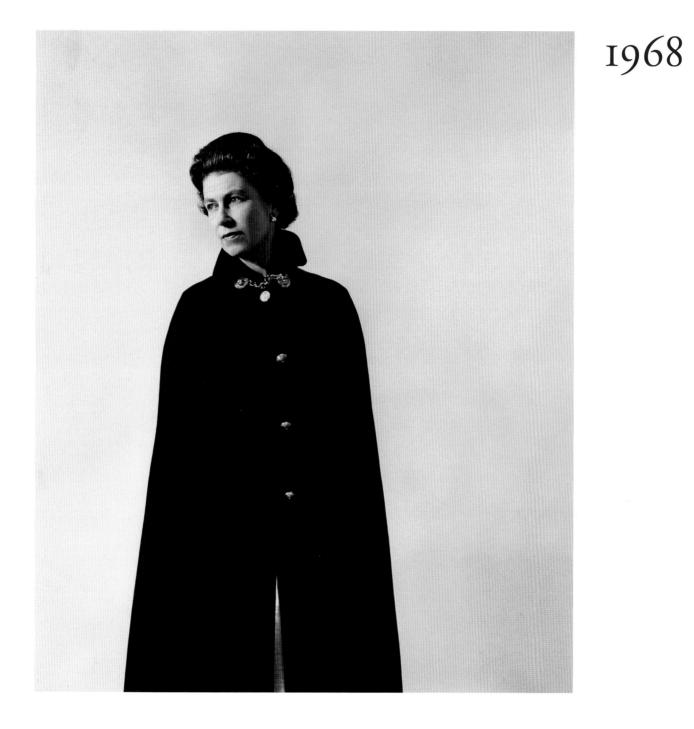

Some of the most memorable images of The Queen were taken by the photographer Cecil Beaton, who died in 1980. The photograph on the previous page is from his last royal sitting, which took place at Buckingham Palace in October 1968. On that occasion Beaton took the unusual step of asking The Queen to wear her admiral's cloak – thus creating a dramatically stark image, quite different from his previous shots of The Queen.

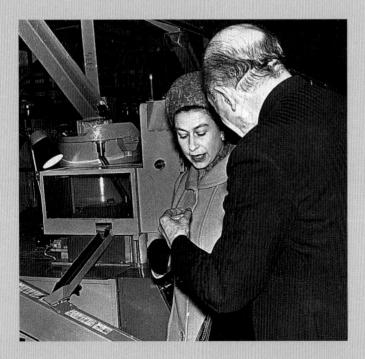

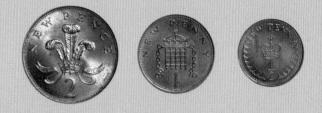

In December 1968 The Queen opened the new Royal Mint in Llantrisant, Monmouthshire. The transfer of the Mint from London coincided with the start of work on the new decimal coinage, which was introduced in 1971. On the occasion of the opening, members of the Royal Family were invited to strike pieces of each of the lowest (and most used) denominations. Prince Charles struck six new 2p pieces, The Queen struck six new 1p pieces, and The Duke of Edinburgh struck six new ¹/₂p pieces. Although struck in 1968, each of the coins bore the date 1971, when they would become legal tender.

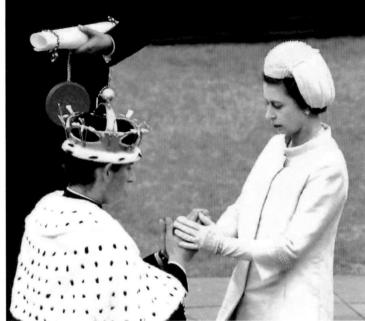

1969

Prince Charles had been created Prince of Wales in July 1958, but it was not until July 1969 that The Queen formally invested him with this title, at Caernarvon Castle. Unusually, the Great Seal attached to the letters patent bearing the royal sign manual was made with blue (rather than red) wax. Most elements of the investiture were specially designed for the occasion by the Earl of Snowdon. The Prince's coronet was made by Louis Osman.

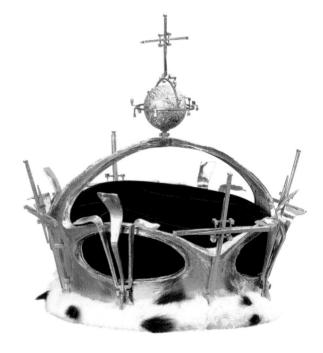

The Queen's five-week visit to Australia, between late March and early May 1970, coincided with the bicentennial celebrations of Cook's 'discovery' of Australia. For much of the visit the Royal Family was based on HMY *Britannia*, here shown being escorted into Brisbane harbour. The tour featured in The Queen's Christmas broadcast of 1970, filmed in her Sitting Room at Buckingham Palace.

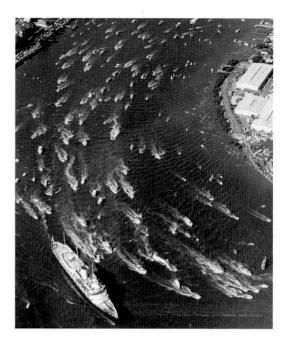

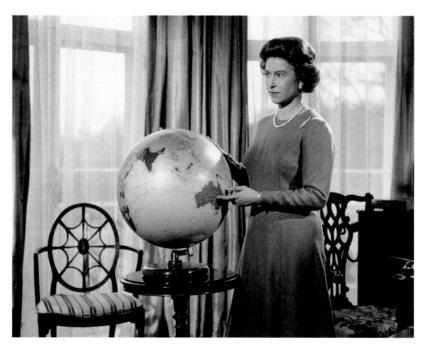

Membership of the Order of the Thistle is the highest honour in Scotland. The Queen is Sovereign Head of the Order and personally appoints Knights Brethren of the Thistle. The Queen and Duke of Edinburgh are here shown at the start of their approach to St Giles' Cathedral, Edinburgh, for the Thistle service in July 1971. The diamond-set Thistle badge and star shown here were both once worn by Prince Albert. The badge was probably made for George IV.

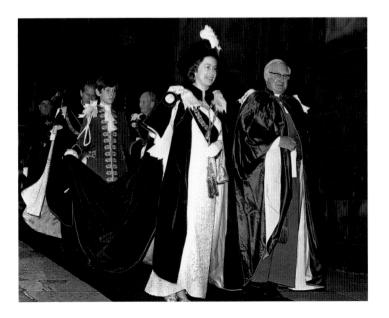

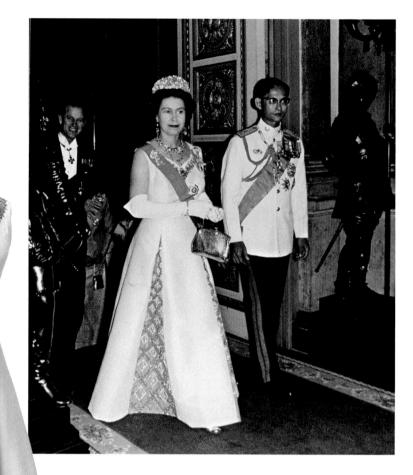

In February and March 1972 The Queen made an extensive tour of South-East Asia and the Indian Ocean. In mid-February she was the guest of King Bhumibol and Queen Sirikit of Thailand. The beaded yellow panels in The Queen's dress match the sash of the Order of Chakri, the Thai national order.

The Silver Wedding Anniversary of The Queen and The Duke of Edinburgh was marked by a Thanksgiving Service in Westminster Abbey, followed by a ceremonial drive to the City of London for lunch at Guildhall. When the royal landau reached the City boundary at Temple Bar, the Lord Mayor made his traditional gesture to the Sovereign by offering her his sword of state, point downwards. As custom dictates, after touching the sword The Queen continued on her way.

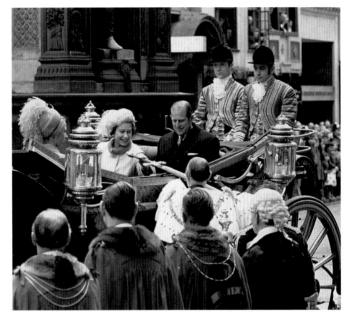

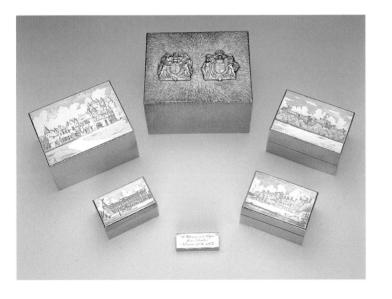

Among the many anniversary gifts to The Queen and Prince Philip was this nest of silver boxes with engraved views of the royal residences. It was commissioned by The Prince of Wales from the goldsmith Gerald Benney.

One of the fixed points in The Queen's calendar is the Royal Maundy Service, on Maundy Thursday (the day before Good Friday). In 1973 the service was held at Westminster Abbey. The number of Maundy Money recipients corresponds to the Sovereign's age. All recipients are pensioners, nominated for their service to the Church and to the community. Each one receives a red bag containing £5.50 in cash, and a white bag containing silver Maundy coins of the same value in pence as The Queen's age.

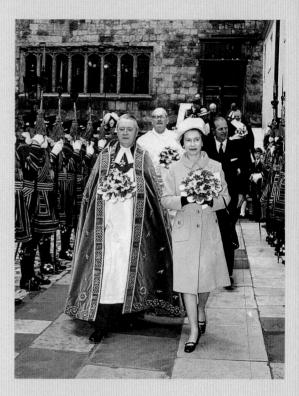

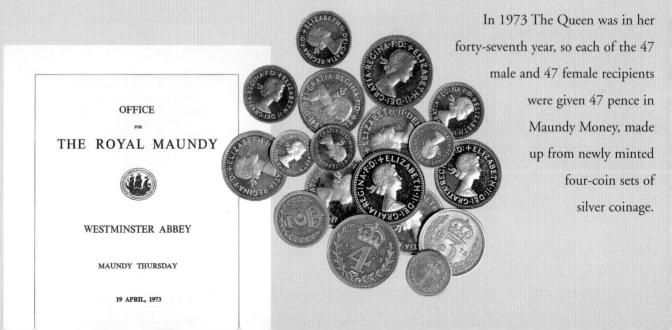

Like the Queen Mother before her, The Queen is a keen admirer of, and participant in, 'the sport of kings'. Her particular interest, as owner and breeder, is flat racing. In 1974 her filly Highclere won both the One Thousand Guineas (below) and the Prix de Diane – the first filly ever to win both races. This painting shows the jockey Joe Mercer riding Highclere in 1974.

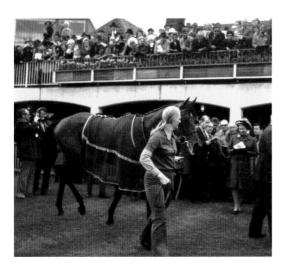

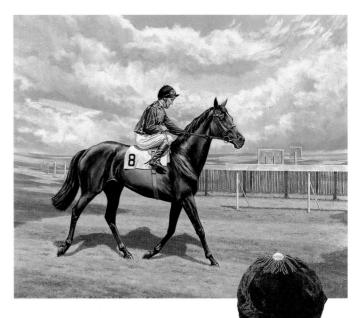

The royal racing colours – purple body with gold braid, scarlet sleeves and black velvet cap with gold tassel – were first registered in 1875 by the future King Edward VII.

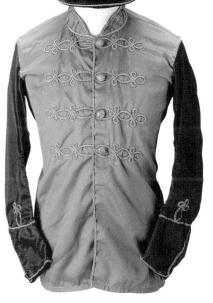

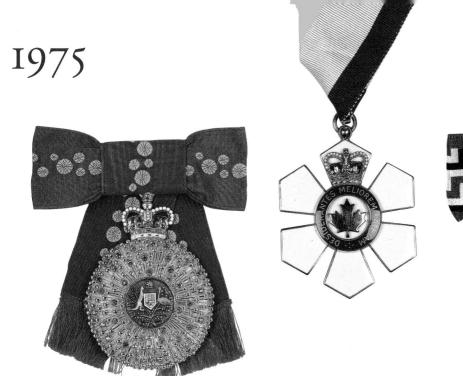

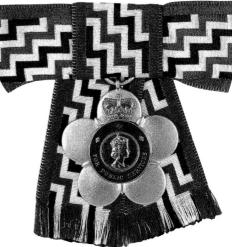

A significant stage of the transition from Empire to a Commonwealth of self-governing nations was reached in 1975 when – on the advice of ministers in the respective countries – The Queen instituted the Order of Australia (left) in February, followed by The Queen's Service Order, New Zealand (right), in March; twelve years later she also instituted the Order of New Zealand. In Canada a similar change had already been heralded by the introduction of the Order of Canada (centre) in 1967, and the Order of Military Merit in 1972. The Queen is Sovereign of each of these Orders.

Among the many gifts which The Queen received in her fiftieth birthday year in 1976 was this engraved glass vase and cover. It was presented by the Royal Company of Archers and shows archers in action, with bows and arrows. It served as the Archers' special royal gift or 'reddendo', to mark the tercentenary of their foundation in 1676, and was presented during The Queen's summer visit to Holyroodhouse. The Royal Company is the Sovereign's bodyguard in Scotland.

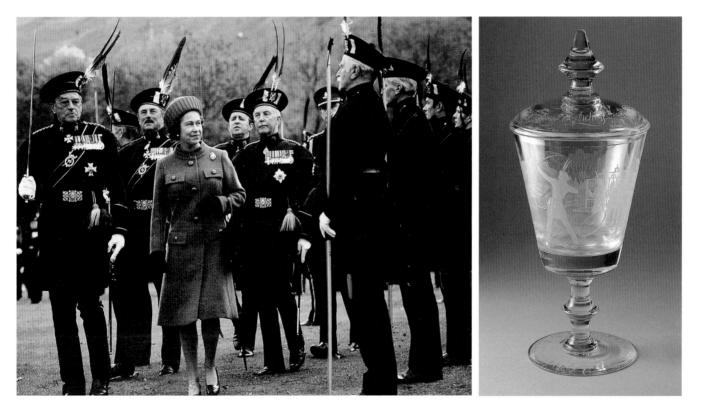

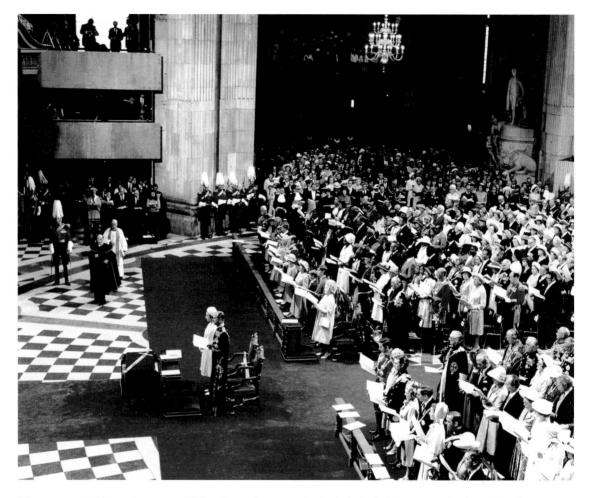

The twenty-fifth anniversary of The Queen's accession was celebrated in 1977. The high point of the Silver Jubilee year was the Service of Thanksgiving in St Paul's Cathedral on 7 June. Street parties were held throughout the country and The Queen's programme included six Jubilee tours in the United Kingdom and Northern Ireland, covering thirty-six counties. Official overseas visits were also made to many Commonwealth countries. The Queen travelled an estimated 56,000 miles in the course of the year.

Congratulatory addresses were presented at ceremonies in Westminster Hall and in Guildhall. This tiny book includes printed transcripts of The Queen's responses to these addresses – all with the keynote of national unity. It is shown here alongside a 25-pence piece issued to celebrate the Silver Jubilee. The Naval Review at Spithead was one of the highlights of the Silver Jubilee year. The Queen, on board HMY *Britannia*, reviewed the fleet assembled in the Solent for the occasion.

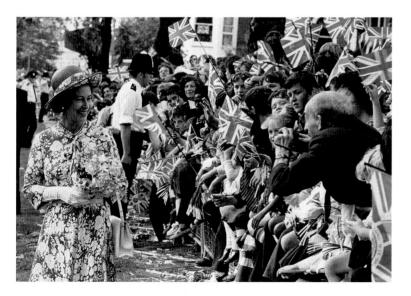

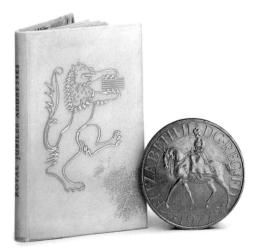

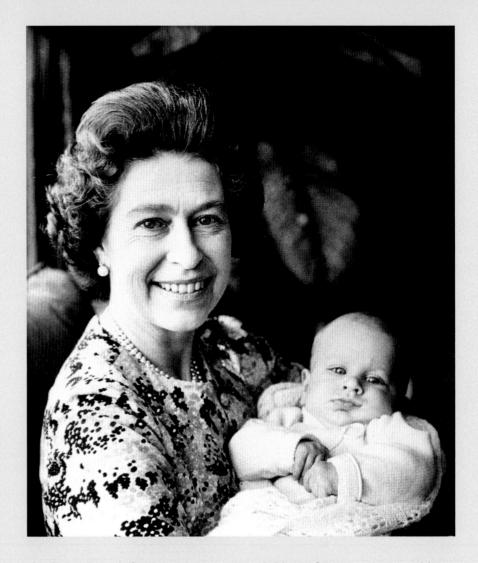

This photograph of The Queen's first grandchild, Peter Phillips, was released on 21 April 1978 to celebrate her fifty-second birthday. Peter Phillips is the elder of the two children of Princess Anne and her first husband, Captain Mark Phillips. The photograph was taken by The Queen's brother-in-law, the Earl of Snowdon.

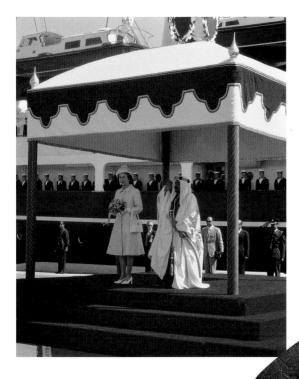

In February and March 1979 The Queen paid an official visit to the Middle East. In Bahrain she was greeted by the Amir (Shaikh Isa bin Sulman Al-Khalifa) under a specially constructed canopy on the quayside, alongside the Royal Yacht. At the time of the State Visit of the Amir to the United Kingdom in April 1984, The Queen was presented with this gold model of the 1979 welcoming ceremony.

0-0-0-0

and the state and

The Contract Contract

In August 1980 Queen Elizabeth The Queen Mother celebrated her eightieth birthday. This photograph of Queen Elizabeth with her two daughters was taken by Norman Parkinson to mark the occasion.

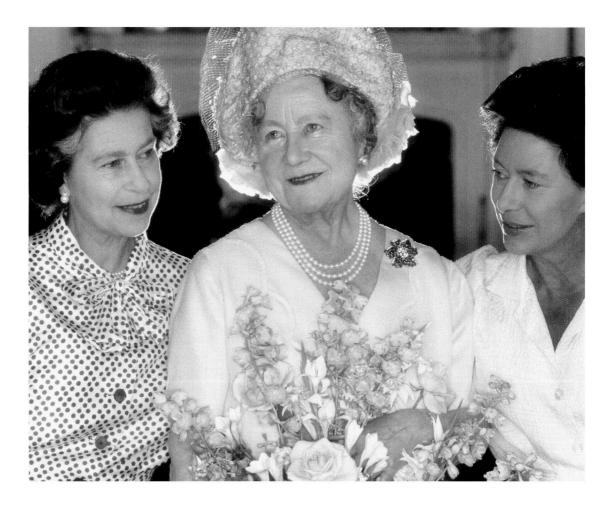

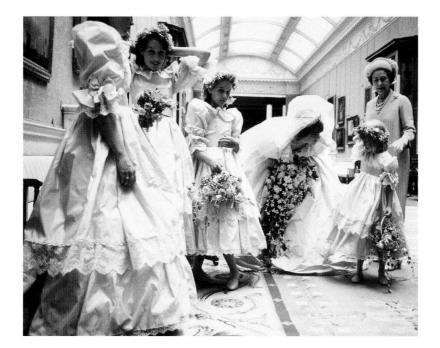

The marriage of The Prince of Wales and Lady Diana Spencer took place at St Paul's Cathedral on 29 July 1981. The Queen and The Princess of Wales gathered with the bridesmaids in the Picture Gallery at Buckingham Palace after the ceremony. The little girl in front of The Queen is Clementine Hambro, the greatgranddaughter of her first Prime Minister, Winston Churchill. The photographer, the Earl of Lichfield, was the grandson of The Queen Mother's brother Jock, and thus The Queen's first cousin once removed.

1981

CEREMONIAL

The Marriage of

HIS ROYAL HIGHNESS THE PRINCE OF WALES with THE LADY DIANA SPENCER at ST. PAUL'S CATHEDRAL on Wednesday 29th July, 1981 at 11.00 a.m.

Prince William, the elder child of The Prince and Princess of Wales, was born on 21 June 1982 and was christened in the Music Room at Buckingham Palace on 4 August. Queen Elizabeth The Queen Mother, whose eighty-second birthday this was, sits on the right in this family group.

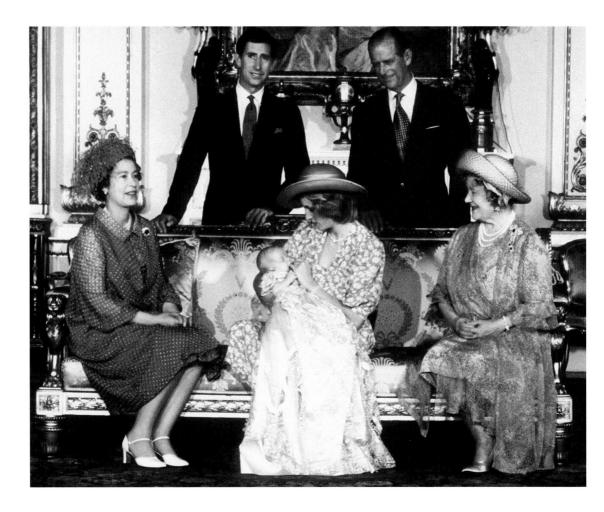

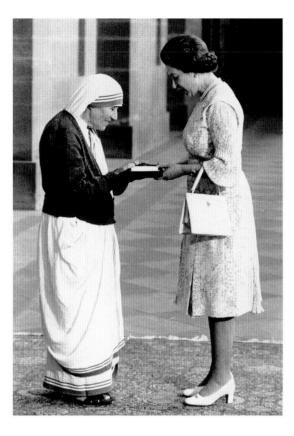

The Order of Merit, founded by King Edward VII in 1902, is awarded by the Sovereign to those who have rendered exceptionally meritorious service. It is in the sole gift of the Sovereign. In a special ceremony at the Rashtrapati Bhavan in November 1983, Mother Teresa of Calcutta became an Honorary Member of the Order. At the time The Queen was attending a meeting of the Commonwealth Heads of Government in New Delhi.

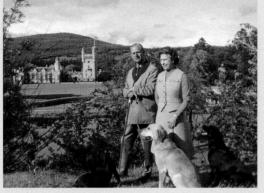

Balmoral Castle, Aberdeenshire, has been one of the Sovereign's private residences since the estate was acquired by Queen Victoria and Prince Albert in 1852. The Queen has visited Balmoral regularly since childhood, and now spends two months there every summer.

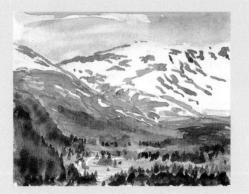

The view of the Dee Valley and Invercauld from Ballochbuie Forest was painted by The Prince of Wales in 1988.

In 1983 she commissioned a series of photographs of the castle from Sir Geoffrey Shakerley, using the viewpoints that had been used for watercolours made for Queen Victoria.

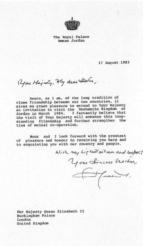

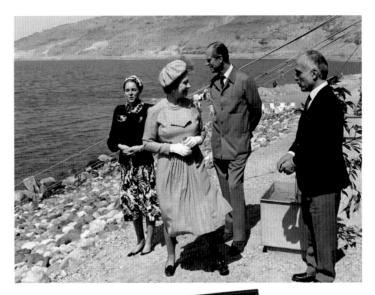

1984

In late March 1984 The Queen and Duke of Edinburgh paid a State Visit to Jordan, as guests of King Hussein and Queen Noor. The King had dispatched the formal invitation leading to this visit in August 1983.

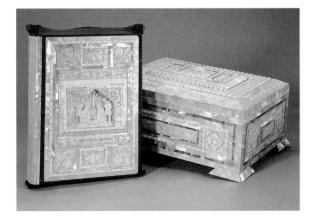

This mother-of-pearl casket, containing a specially bound copy of the King James Bible, was a gift to The Queen from King Hussein in 1966.

Each year the Sovereign's official birthday in June is marked by The Queen's Birthday Parade on Horse Guards, Whitehall. The Queen took the salute on horseback (riding side-saddle) from 1947 until 1986. Her mount from 1969 was Burmese (1962–90), a black mare bred and presented by the Royal Canadian Mounted Police. Following Burmese's retirement in 1986, The Queen has been driven the short distance between Buckingham Palace and Horse Guards in the Ivory Phaeton.

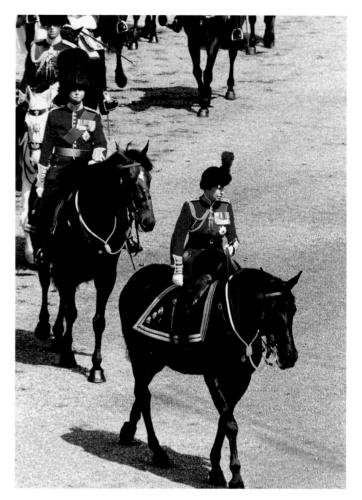

The Queen's side-saddle and Burmese's head-collar are both kept at Windsor. The head-collar also gives the names of Burmese's sire and dam.

The Queen personally takes the salute as the Colour is 'trooped' before her. The Guards regiments take turns to troop their Colour. In 1978 (below) it was the turn of the Grenadier Guards. The colour of the plume in The Queen's hat changes according to the regiment whose colour is being trooped. In 1985 (see opposite) a red plume was worn for the trooping of the Coldstream Guards' Colour.

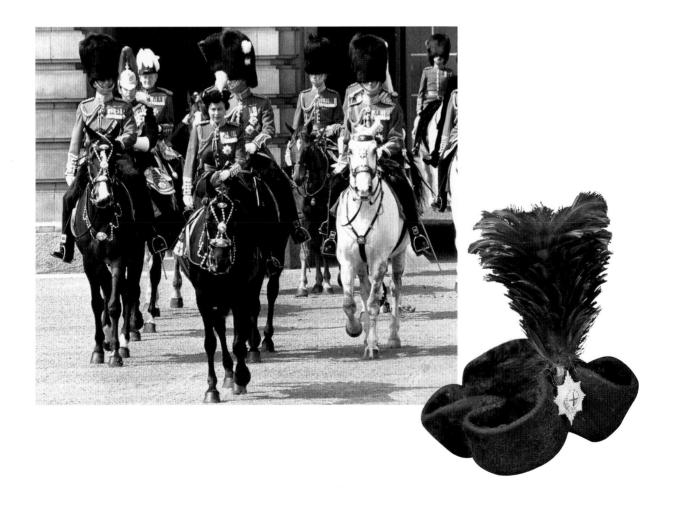

Prince Andrew's photograph of The Queen was released in April 1986 to mark her sixtieth birthday. It was taken at Sandringham House, Norfolk, the private royal residence purchased for the future King Edward VII in 1862.

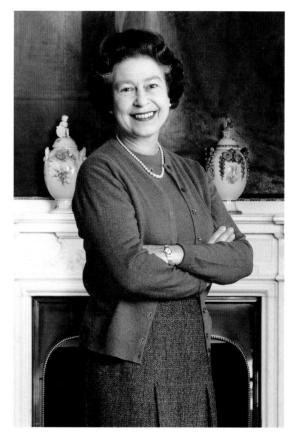

A vignette of The Queen on horseback in front of Sandringham House was included by Graham Rust in this bookplate design, a sixtieth birthday present from Princess Alexandra and The Hon. Angus Ogilvy. In October 1986 The Queen and Duke of Edinburgh paid their first State Visit to China, as guests of President Li Xiannian. As well as being photographed among the terracotta warriors at Xian, The Queen herself photographed the Duke – for her own photograph album.

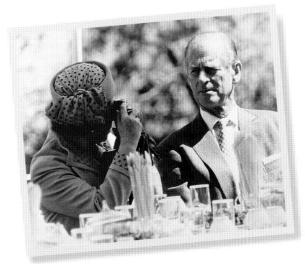

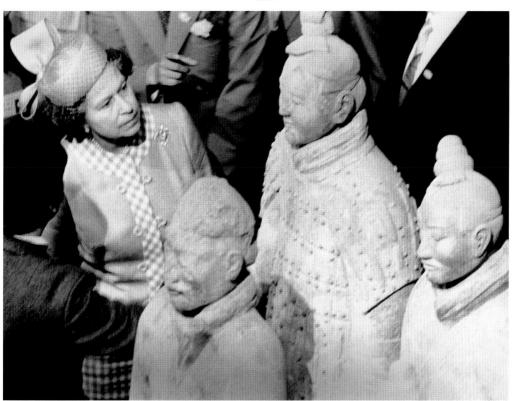

1986

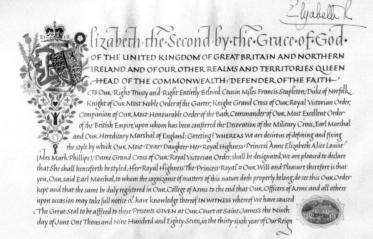

BY THE QUEEN OF THE UNITED KINGDOM OF GREAT BRITAIN AND NORTHERN IRELAND AND OF HER OTHER REALMS AND TERRITORIES Signal with Horowa Hand

In June 1987 The Queen bestowed the title of Princess Royal on her only daughter, Princess Anne. The Princess began to undertake public engagements at the age of 18. In 1970 she was appointed President of the Save the Children Fund, in which she has been particularly active. The Princess Royal is also well known internationally as an Olympic-class horsewoman, and was elected to the International Olympic Committee in 1988.

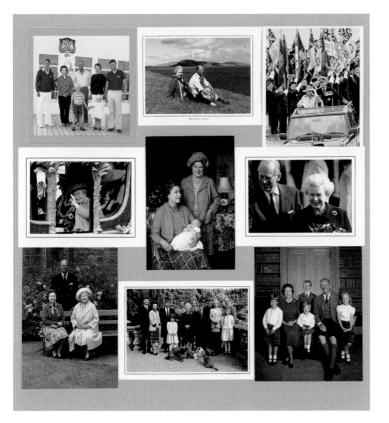

Each year The Queen and Duke of Edinburgh send about 750 Christmas cards, normally including a photograph from the past year on the cover. In 1988 the card (in the centre here) incorporated the Duchess of York's photograph of three generations of the Royal Family at Balmoral: The Queen holds the infant Princess Beatrice of York, born on 8 August, while Queen Elizabeth stands behind. The other cards shown here date from the last two decades.

Sir Hugh Casson included this festive scene in a letter to The Queen.

The extraordinary events of 1989 included the April visit of President Gorbachev of the USSR to Windsor Castle as the guest of HM The Queen. In early November of the same year the wall dividing East and West Berlin was demolished and – like many Western heads of state – The Queen was sent a portion of the demolished wall by the People of Germany. The Cold War appeared to be at an end.

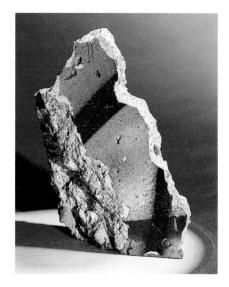

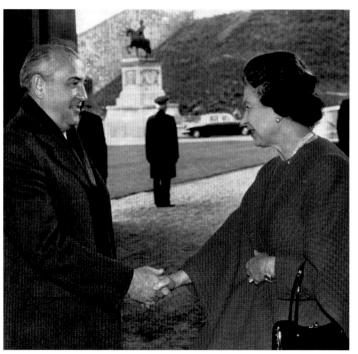

Friday, 7th April, 1989 at 1.00 p.m.

> The Chairman of the Presidium of the Supreme Soviet of the USSR and Mrs. Gorbachev have been invited to lunch.

From: The Deputy Private Secretary 28th March, 1989.

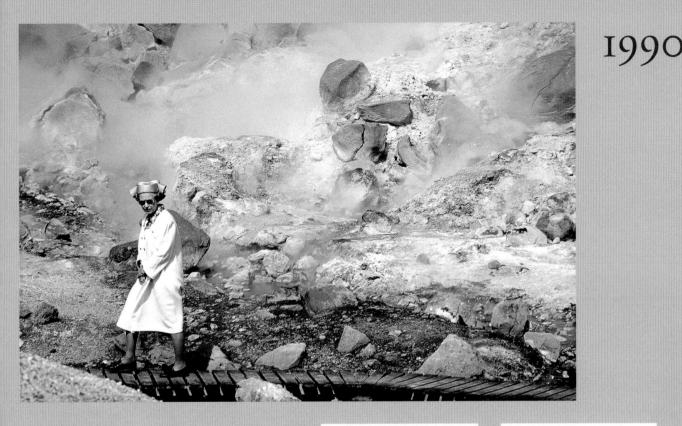

The Queen's first visit to Iceland took place in late June 1990, when she was the guest of President Vigdis Finbogadottir. On the last day she was photographed walking through the evil-smelling hot sulphur springs at Krisuvik.

STATE VISIT TO ICELAND

OF HER MAJESTY QUEEN ELIZABETH II AND HIS ROYAL HIGHNESS THE PRINCE PHILIP, DUKE OF EDINBURGH

25-27 JUNE 1990

Wednesday, 27 June

- 10:15 a.m. Departure by car (5 kms)
- 10:25 a.m. Arrival at Fossvogur Cemetery Wreath-laying Ceremony at Commonwealth War Graves in the presence of Veterans and the British Community
- 10:45 a.m. Departure by car for Bessastaðir A moment of prayer in the Church Continue to Krísuvík Geothermal Area
- 12:45 p.m. Arrival at Keflavik International Airport 12:55 p.m. His Royal Highness The Prince Philip. Duke of Edinburgh, departs in an aircraft of the Queen's Flight for the United Kingdom
- 1:00 p.m. Her Majesty Queen Elizabeth II departs in a Canadian Forces Aircraft for Canada

In May 1991 The Queen revisited the United States, as the guest of President George Bush. Her programme included a formal address to a meeting of both Houses of Congress. In the course of the visit she received this engraved glass flower bowl, decorated with references to flowers in Shakespeare's works.

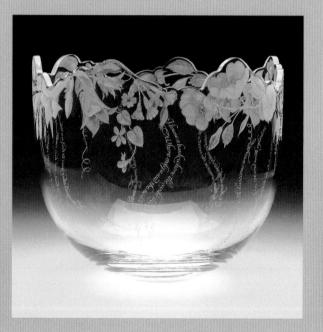

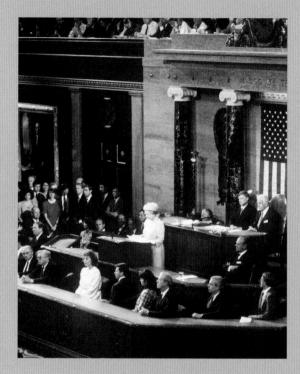

THE STATE VISIT TO WASHINGTON,D.C. OF HER MAJESTY QUEEN ELIZABETH II OF THE UNITED KINGDOM OF GREAT BRITAIN AND NORTHERN IRELAND AND HIS ROYAL HIGHNESS THE PRINCE PHILIP DUKE OF EDINBURGH

MAY 14 TO 17, 1991

11:25 am Mr. Russ, Ms. Pope, and the Congressional Escort Committee escort The Queen and The Duke of Edinburgh to the Greet Nall of the United States House of Representatives via the Center

WASHINGTON, D.C.

THURSDAY MAY 16, 1991 (Continued)

- 11:29 am The Queen, accompanied by The Duke of Edinburgh, is enounced by Mr. James Nalay, Dorkheeper of the United States House of Representatives, to The Honorable Thomas 5. Poley, Speaker of the United Ritche House of Representatives.
- 11:30 am Address by Mer Majesty Queen Elizabeth II of the United Kingdom of Great Britain and Northern Ireland before a Joint Meeting of the United States Compress in the Great Mall of the United States Nouse of Representatives at the United States Capitol.

-75-

At the conclusion of the Address, The Queen, accompanied by The Duke of Edinburgh, is escorted to the Speaker's Room, H-204, by Mr. Russ and Ms. Pope.

The year 1992 was one of mixed fortunes. It began with the fortieth anniversary of The Queen's accession, on 6 February, which was marked by Ted Hughes with his poem 'The Unicorn'.

X-Ray Forty years Invisibly The spine of a people Pillas Of the scales TIL The Unicorn Where shelt and hight . In alternation Forty years The Unicorn Has kept watch. Her Lion sleeps Fnul Tremple. The fulcture 10000 met her eyes Ochina her eyes In the people. While the Hyena haughing cries: I thes all in supprise Faity years Neighing The people. Just made a Queen have been On a front page these equality british In This much an Yet five ill. Her Lion Dreams. His colour runs Supported Hover , win years later Kogkung at las All see the consin. All see the motion Somes has site. Ours, their life. Some, their life. Into hes corgis Bound by neither. So free upright To be reas. They are his imps. But he will wake Only for War. Level Ensied.

THE UNICORN

For The Fortieth Anniversary Of The Accession Of Her Majesty Queen Elizaberth IL

6th February 1992

by The Poet Laureate Ted Hughes

On 20 November – The Queen's forty-fifth wedding anniversary – a major fire broke out at Windsor Castle. Parts of both the State and the Private Apartments were destroyed, but over the next five years a major restoration programme was completed. In the new Private Chapel the stained-glass window, designed by The Duke of Edinburgh, records the fire-fighting and salvage operation.

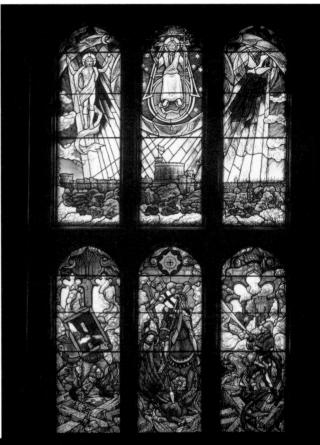

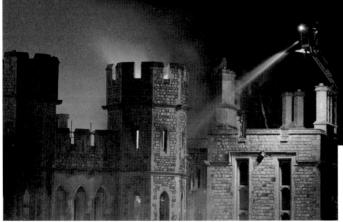

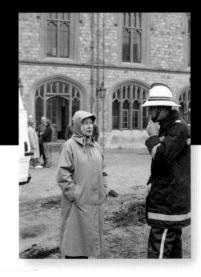

In June 1993 The Queen visited Northern Ireland for the seventh time in her reign, attending a reception, lunch and garden party at Hillsborough Castle, Belfast.

1993

The Channel Tunnel was officially opened by The Queen and President Mitterand of France in May 1994, after many years of discussion and engineering work. A fragment of the inaugural ribbon cut by Queen and President was kept as a souvenir, together with the gilt commemorative medal.

The fiftieth anniversary of VE Day, which marked the end of the Second World War in Europe, was celebrated in May 1995. The same three royal ladies were photographed in the same location – the balcony at Buckingham Palace – fifty years before.

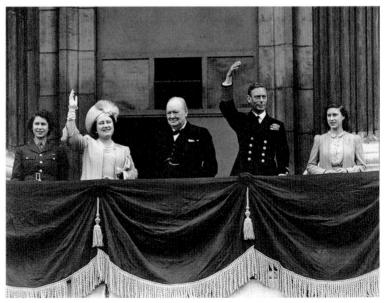

1995

The visit of Nelson Mandela, President of South Africa, to London in July 1996 marked an important point in the relationship between the two countries. The Queen was photographed standing beside the President before the State Banquet held at Buckingham Palace in his honour.

STATE BANQUET

THE PRESIDENT of the REPUBLIC OF SOUTH AFRICA

BUCKINGHAM PALACE TUESDAY, 9th JULY, 1996

> Among the gifts that President Mandela brought to London was this silk headscarf, decorated with animals and hunters.

The tragic death of Diana, Princess of Wales, at the end of August 1997 led to a national outpouring of grief. On the day before the Princess's funeral The Queen and Duke of Edinburgh viewed the tributes left outside the gates of Buckingham Palace.

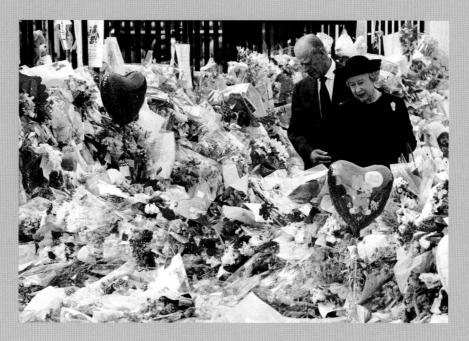

In November a Thanksgiving Service was held at Westminster Abbey to celebrate the Golden Wedding Anniversary of The Queen and Duke of Edinburgh.

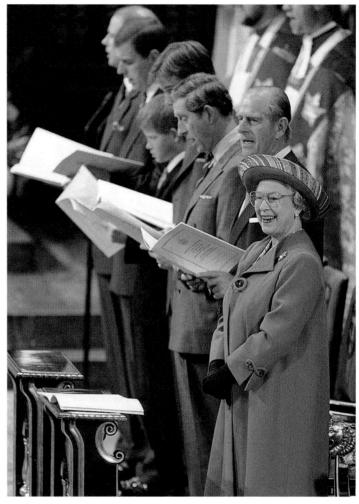

Princess Margaret's wedding anniversary present to her sister and brother-in-law was a glass jug with the initials E and P overlaid in gold around the neck.

In the following year The Prince of Wales celebrated his fiftieth birthday. On the eve of his birthday The Queen gave a party at Buckingham Palace to celebrate The Prince's public work. Among the guests were many associated with his charities. The Queen made a congratulatory speech in the course of the evening, to which The Prince responded.

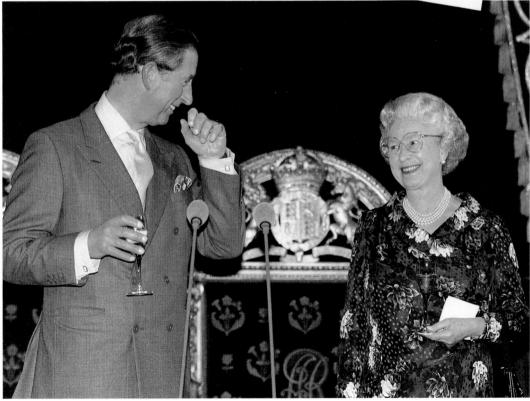

The end of the second millennium was marked by a reception, attended by The Queen and her Prime Minister, in the new Millennium Dome at Greenwich. The Queen had been shown a model of the dome during her visit to the Royal Institution of Chartered Surveyors in July 1999.

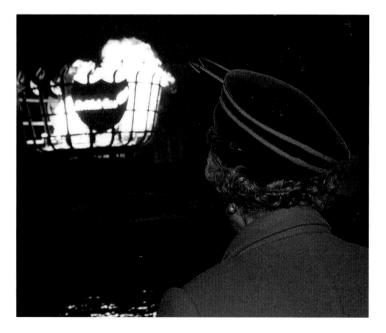

On a barge in the River Thames at Greenwich, The Queen lit the flame that fired the National Millennium Beacon, the first in a string of 10,000 beacons to be lit across the nation.

you look Butheday

You this opecial day

BUCKINGHAM PALACE

ROYAL MAIL

100

The Voune

sending

best wishes

SWIA IB.

In August, Queen Elizabeth The Queen Mother celebrated her hundredth birthday. The Queen's personalised telegram was delivered to Clarence House before the Royal Family gathered at Buckingham Palace for lunch and the traditional balcony appearance.

The Queen and Duke of Edinburgh were received in audience by Pope John Paul II during their visit to the Vatican in October 2000. The Queen's gift to the Pope was a set of facsimiles of Canaletto drawings in the Royal Collection. The white leather box containing the facsimiles was specially bound for the occasion in the Royal Bindery at Windsor, and stamped with the official crowned EIIR tool.

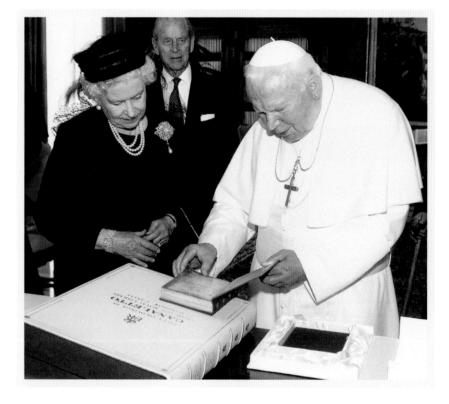

The annual Remembrance Sunday Service at the Cenotaph, Whitehall, each November is a key event in the royal calendar. On this occasion the whole nation, led by the Sovereign, pays homage to those who have died in the service of their country. The Queen has attended the service from her earliest years. She is here shown in contemplation during the two-minute silence at the service in 2001, shortly before laying her wreath.

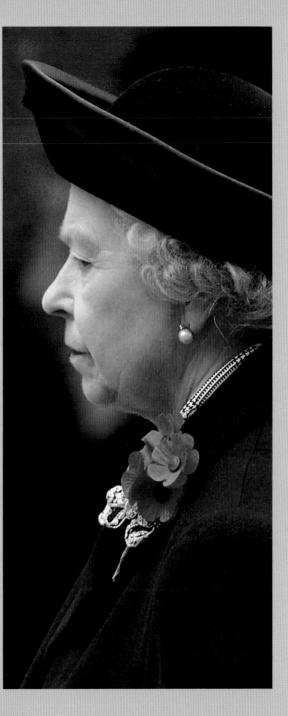

2001

The Golden Jubilee year opened with the deaths of two of The Queen's closest relations – first Princess Margaret, in February; and then Queen Elizabeth, in late March. Before The Queen Mother's funeral in Westminster Abbey, her coffin lay in state in Westminster Hall. This watercolour, commissioned by The Queen, shows the catafalque guarded by Queen Elizabeth's four grandsons.

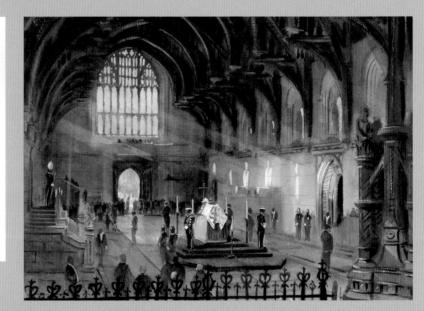

For the remainder of the Jubilee year, The Queen resumed her round of public duties. In this photograph she wears the Family Orders of King George VI and King George V, with Garter Star and sash, and the Grand Duchess Vladimir's tiara, set with pearls.

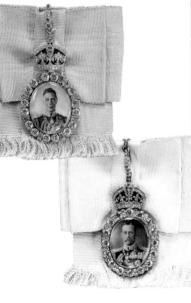

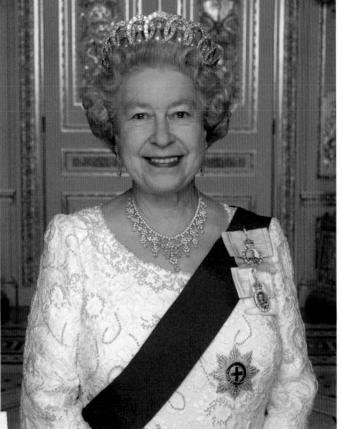

2002

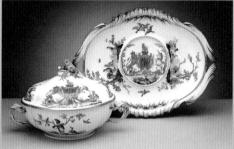

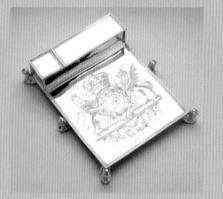

Super flumins Babylonis. Ce Decet lymnus. U ente ceutemus bomino. Herba mea suribus percipe bo. Hoce mea ad bominum. Hoce mea ad bominum. Hoce mea ad bominum. Haquequo bomine obluiteris me. Haquid bcus republikt in finem. Crrví. lxiii. rciii. v. lrrví. crlí. rtí. lrrití. FIRIS. No crokent legge no blered eye no part enformed out of kingte nor yet to ouglye halfe en be as is the numarel infoicious numbe. our Loumoe man (IDIA) Mijer e' chi speme in roja. mortal pone P

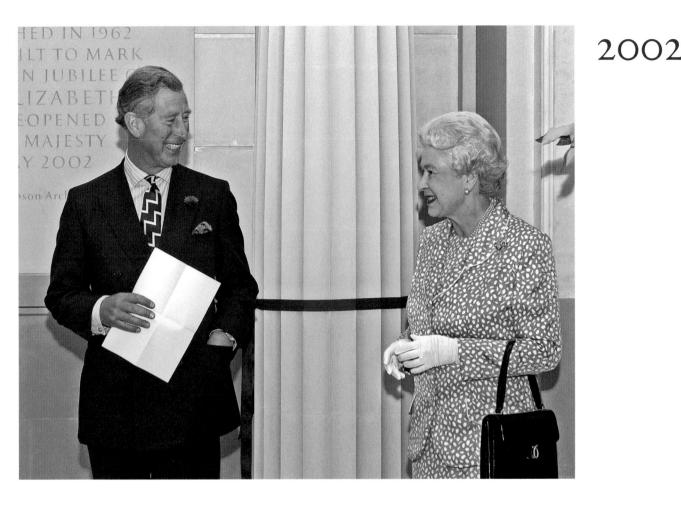

The Golden Jubilee year was also marked by the opening of two new Queen's Galleries, in London and Edinburgh. The Prince of Wales, Chairman of the Royal Collection Trustees, greeted The Queen prior to the opening of the new Queen's Gallery at Buckingham Palace in May. The first exhibition, *Royal Treasures*, included many of the additions made to the Royal Collection during The Queen's reign, some of which are shown opposite.

Prince William celebrated his twenty-first birthday in June 2003, and appeared with The Queen on the balcony of Buckingham Palace to watch the flypast after the Trooping the Colour ceremony in the same month.

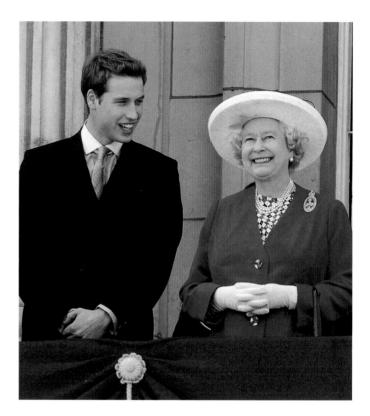

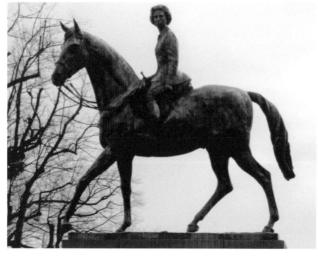

This photograph, taken by The Duke of Edinburgh, shows Philip Jackson's equestrian figure of The Queen, which was unveiled in Windsor Great Park in 2003. It was the Golden Jubilee gift to the Sovereign from the Crown Estate.

At the end of her eighth decade The Queen is still an active horsewoman. This photograph was taken at Windsor on 10 April 2004. The Queen rides Tinkerbell, while her granddaughter Zara Phillips (on the left) rides Tiger Lily, Tinkerbell's daughter, and The Princess Royal (on the right) rides Peter Pan, Tinkerbell's son. Forty years earlier, The Queen is shown enjoying a gallop along the racecourse at Ascot.

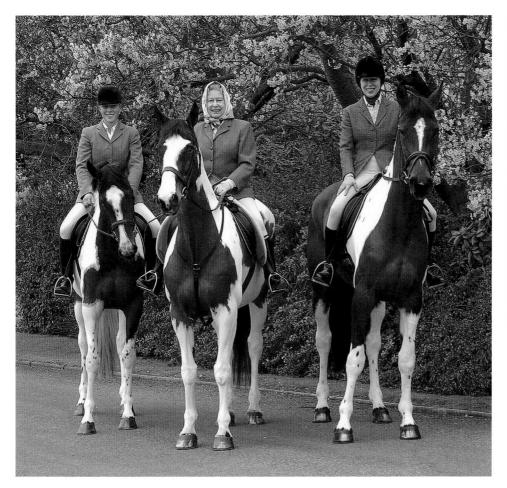

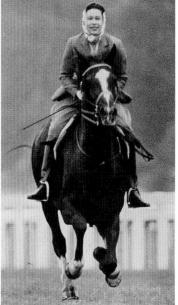

The Prince of Wales's marriage to Camilla Parker Bowles in April 2005 was an event of particular happiness for the Royal Family. The Queen is shown with The Prince of Wales and The Duchess of Cornwall at the reception in St George's Hall following the marriage and Thanksgiving Service.

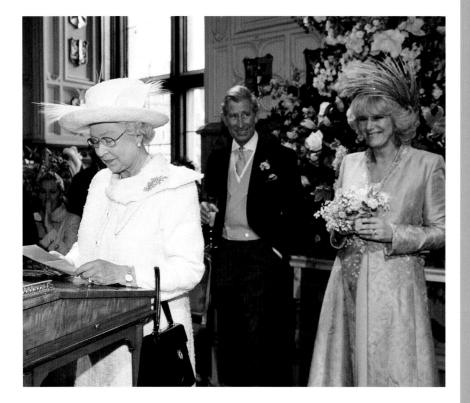

ST PAUL'S CATHEDRAL

A SERVICE OF REMEMBRANCE LONDON 2005

> Tuesday 1 November All Saints' Day 1500

After the London bombings in July 2005, The Queen shared in the national grief and mourning. She was present at the Memorial Service at St Paul's on All Saints' Day, 1 November.

The Queen celebrated her birthday at Windsor in April 2006, followed by national celebrations in London in June. This eightieth birthday portrait was taken by Jane Bown, born one year before The Queen.

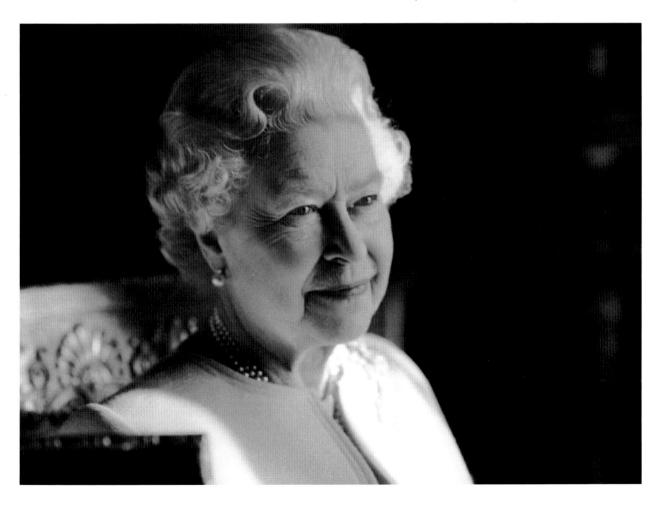

ILLUSTRATIONS

IS Martin Country Coun

Unless otherwise stated, all illustrations are The Royal Collection © 2006, HM Queen Elizabeth II. Items with RA references are: The Royal Archives © 2006, HM Queen Elizabeth II. Royal Collection Enterprises are grateful for permission to reproduce those items listed below for which copyright is not held by the Royal Collection or Royal Archives.

1926

 No.17 Bruton Street, London WI (RCIN 2002127): Copyright Reserved/The Royal Collection

Princess Elizabeth of York, May 1926 (RCIN 2999931): photograph by Speaight Ltd;
Copyright Reserved/The Royal Collection
The Duke of York and Princess Elizabeth of York, 1926 (RCIN 2999845): photograph by Marcus
Adams; photograph: The Royal Collection;
reproduced by kind permission of Rosalind Adams
Family group following the Christening of Princess
Elizabeth of York, 29 May 1926 (RCIN 2999930)
Princess Elizabeth silver christening cup: Henry
Hodson Plante, 1926 (RCIN 50931)

1927

• Princess Elizabeth of York with her grandmother, the Countess of Strathmore, 1927 (RCIN 2999917): photograph by Frederick and Hubert Thurston; Copyright Reserved/The Royal Collection

• Princess Elizabeth of York in chair, May 1927 (RCIN 2999927): photograph by Frederick and Hubert Thurston; Copyright Reserved/The Royal Collection

 Princess Elizabeth of York on window ledge, May 1927 (RCIN 2999928): photograph by Frederick and Hubert Thurston; Copyright Reserved/ The Royal Collection

1928

 Princess Elizabeth of York pushing a dolls' pram, 1928: photograph by Jack Esten, Camera Press London

• The Duchess of York and Princess Elizabeth of York, July 1928 (RCIN 2999916): photograph by Marcus Adams: photograph: The Royal Collection; reproduced by kind permission of Rosalind Adams

• Doll: Simon & Halbig/Kammer & Reinhart, c.1910 (RCIN 64204)

1929

• Princess Elizabeth of York with lilies, 1929 (RCIN 2999926): photograph by The Duke of York (later King George VI)

1930

 Princess Elizabeth of York with Queen Mary, at the Naval and Military Tournament, 29 May 1930 (RCIN 2999842): Copyright Reserved/The Royal Collection

 Princess Elizabeth of York in an open carriage outside No 145 Piccadilly (RCIN 2999841): Copyright Reserved/The Royal Collection

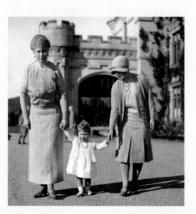

1931

• 'Lilibet's first letter' to Queen Mary, April 1931 (RA GV/CC 14/63)

• Princess Elizabeth of York riding a tricycle, 1931 (RCIN 2002135): Copyright Reserved/ The Royal Collection

• Princess Elizabeth of York and the Countess of Airlie, Glamis, 1931 (RCIN 2999840): Copyright Reserved/The Royal Collection

1932

 Princesses Elizabeth and Margaret of York on a rocking horse at St Paul's Walden Bury, August 1932 (RCIN 2999918): photograph by Frederick Thurston; Copyright Reserved/ The Royal Collection

• Princess Elizabeth of York on her Shetland pony (RCIN 2999839): Copyright Reserved/ The Royal Collection

1933

• Philip de László, *Princess Elizabeth of York*, 1933 (oil on canvas; RCIN 409002)

 King George V and Queen Mary, with the Duchess of York and Princesses Elizabeth and Margaret, outside Y Buthyn Bach, May 1933 (RCIN 2999838): photograph by Princess Victoria

1934

• Letter from Princess Elizabeth to Queen Mary, 16 February 1934 (RA GV/CC 14/65)

 Princess Elizabeth of York as a bridesmaid at the wedding of the Duke and Duchess of Kent, 29 November 1934 (RCIN 2999837): photograph by Bassano

1935

 Princesses Elizabeth and Margaret of York shopping in Forfar (leaving Mr Shepherd's bookshop in Castle Street), August 1935 (RCIN 2999836): Copyright Reserved/The Royal Collection
 Princesses Elizabeth and Margaret of York, November 1934, inscribed and dated 1935 (RCIN 2999835): photograph by Marcus Adams; photograph: The Royal Collection; reproduced by kind permission of Rosalind Adams

1936

• Princess Elizabeth of York during a visit to Professor de Stróbl's studio, 1935/6 (RCIN 2999834): photograph by Lajos Lederer;

Copyright Reserved/The Royal Collection • Sigismund de Stróbl, *Princess Elizabeth*, 1937

(marble; RCIN 101407)

• Princess Elizabeth of York holding Jane (RCIN 2999833): photograph by Studio Lisa, Camera Press London

• Princess Elizabeth's account of the Coronation of King George VI and Queen Elizabeth, 12 May 1937 (RCIN 1080431)

• King George VI, Queen Elizabeth, Princess Margaret and Princess Elizabeth, in their coronation robes, May 1937 (RCIN 2999915): photograph by Dorothy Wilding: photograph: The Royal Collection; reproduced by kind permission of Tom Hustler

• Princess Elizabeth's gold coronet: Garrards, 1937 (RCIN 75056)

1938

• The dolls France and Marianne: Jumeau, 1938 (RCIN 93160, 93161)

• Letter from Princess Elizabeth to Queen Mary, 15 November 1938 (RA GV/CC 14/85)

 Princesses Elizabeth and Margaret looking at Marianne, during the exhibition at St James's Palace. © Royal London Hospital Archives; courtesy of Royal London Hospital Archives

1939

• Letter from Princess Elizabeth to Queen Mary, 27 March 1939 (RA GV/CC 14/89)

 Princess Elizabeth on her 13th birthday (21 April 1939), riding at Windsor with King George VI and Princess Margaret (RCIN 2002139): Copyright Reserved/The Royal Collection

• Princess Elizabeth's saddle: George Parker (RCIN 93812)

1940

 Princess Elizabeth's first radio broadcast, 12
 October 1940 (RCIN 2002152): Popperfoto.com
 Message from Princess Elizabeth to British children abroad, 13 October 1940 (ptivately printed, New York; RCIN 1057564): Copyright Reserved/The Royal Collection

1941

• Jardinière brooch, 1941 (RCIN 200164)

• Princesses Elizabeth and Margaret gardening at Windsor, 1941 (RCIN 2002153): photograph by Studio Lisa; Copyright Reserved

1942

 Princess Elizabeth in Girl Guide uniform, with identity card, 5 May 1942 (RCIN 2002184): Popperfoto.com

 Princess Elizabeth's ration books and identity card (RA GVI/PRIV/PERS and RA PS/GVI/ C 233/04 and 12-15): Crown Copyright material, reproduced with the permission of the Controller of HMSO and The Queen's Printer for Scotland; photograph: The Royal Archives
 2006, HM Queen Elizabeth II

1943

• Programme for Aladdin, 16 December 1943 (RA F&V/PRFF/1943)

 Cast photograph of 'Aladdin' in Waterloo Chamber, Windsor Castle, Christmas 1943 (RCIN 2999832): photograph by Studio Lisa; Copyright Reserved

1944

 Princess Elizabeth receiving the Colonel's Colour of the 1st Battalion Grenadier Guards on her 18th birthday at Windsor, 21 April 1944 (RCIN 2999897): photograph by Bill Warhurst:
 © The Times, London, 22.04.1944

The Colonel's Colour of the 1st Battalion Grenadier Guards, presented to Princess Elizabeth, 21 April 1944 (RCIN 98009)
Aquamarine and diamond clips: Boucheron, 1944 (RCIN 200135)

• Sapphire and diamond bracelet: Cartier, 1944 (RCIN 200139)

 Princess Elizabeth with pony and Windsor Horse Show cup, 1944 (RCIN 2999911): photograph by Studio Lisa; Copyright Reserved
 Silver cup won by Princess Elizabeth at the

Windsor Horse Show, 1944: Charles Boyton & Sons, *c*.1905 (RCIN 50932)

1945

 Princess Elizabeth engaged in vehicle maintenance duties, as a member of the ATS, April 1945 (RCIN 2002230): photograph by IWM, Camera Press London

• Princess Elizabeth's ATS uniform: photograph by Joe Little

• Detail of name tape in Princess Elizabeth's ATS uniform: Newsteam.co.uk

1946

 Princess Elizabeth launches Britain's giant new aircraft carrier, HMS Eagle, at Harland and Wolff shipyard, Belfast, 19 March 1946 (RCIN 2002266): Copyright Reserved/The Royal Collection

 Princess Elizabeth, wearing the robe of an Ovate, received into the order of Druids by the Arch-Druid, at the National Eisteddfod of Wales, Mountain Ash, 6 August 1946 (RCIN 2002291): Copyright Reserved/The Royal Collection

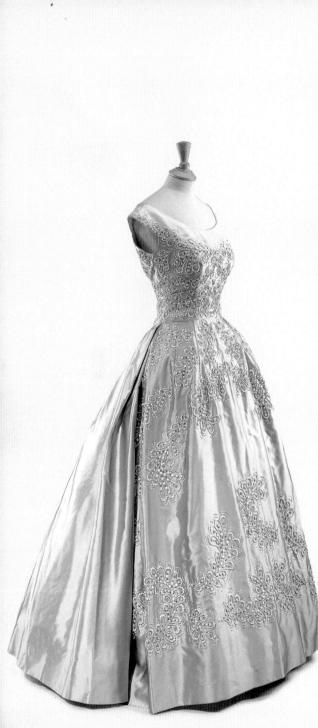

• Princesses Elizabeth and Margaret on HMS Vanguard, with the ship's cat, during the Royal Tour of South Africa, 1947 (RCIN 2999831): Copyright Reserved/The Royal Collection

 Princesses Margaret and Elizabeth on the footplate of one of the engines hauling the Royal Train, with the South African Minister of Transport (Hon F.C. Sturrock), in South Africa, March 1947 (RCIN 2002312): Popperfoto.com

• Diamond necklace and bracelet, 1947, altered 1952 (RCIN 200152-3)

 John Masefield, 'On the coming marriage of Her Royal Highness, The Princess Elizabeth', 1947; calligrapher Dorothy Hutton (RCIN 1047157): Copyright Reserved/The Royal Collection; reproduced with permission of the Society of Authors as the Literary Representatives of the Estate of John Masefield

Princess Elizabeth's diamond engagement ring: Philip Antrobus Ltd, 1947 (RCIN 200165)
Princess Elizabeth and The Duke of Edinburgh

leaving Westminster Abbey following their marriage, 20 November 1947 (RCIN 2002399): photograph TPS, Camera Press London • Order of Service for the Marriage, and Queen Mary's invitation to the Wedding Breakfast, 20 November 1947 (both RA F&V/Weddings/ 1947/QEII)

1948

- Announcement of the birth of Prince Charles,
- 14 November 1948 (RA PS/GVI/PS 09091/6)
- Flower basket brooch, ?1920s (RCIN 200140)
- · Princess Elizabeth with the infant Prince Charles,

14 December 1948 (RCIN 2999884): photograph by Cecil Beaton; photograph:

The Royal Collection; © V&A Images/Victoria and Albert Museum

1949

- The Duke of Edinburgh and Princess Elizabeth on the roof of the Villa Guardamangia, Malta, 1949 (RCIN 2706274): Copyright Reserved/ The Royal Collection
- Crocheted cotton mat, 1949 (RCIN 94724)
 - Silver figure of St George and the Dragon: designed by Edward Seago, 1948 (RCIN 200163)
 - Rolls-Royce Phantom IV: coachwork by H.J. Mulliner & Co. Ltd, 1948 (RCIN 2002547): photograph copyright Rolls-Royce Ltd

1950

 The Duke of Edinburgh with Princess Elizabeth, Prince Charles and the infant Princess Anne, 1950 (RCIN 2999830): photograph by Baron Studios

1951

• The Duke of Edinburgh and Princess Elizabeth, at the Royal 'Barn Dance', Rideau Hall, Ottawa, October 1951 (RCIN 2003262, 2003264): both photographs by Frank Royal; © 1951 National Film Board of Canada

• Black velvet and silk dress: Norman Hartnell, ?1950s (RCIN 100037)

1952

The Queen arriving at London Airport from Kenya, 9 February 1952 (RCIN 2999978): Copyright Reserved/The Royal Collection
The Williamson diamond brooch: Cartier, 1952 (RCIN 200146)
Edward Halliday, Maundy Thursday, 1952 (oil on canvas; RCIN 404800): Copyright Reserved/The Royal Collection
Jewelled gold bracelet: Boucheron, to a design by The Duke of Edinburgh, 1952 (RCIN 200151)
The Queen at Sandringham, making her first

• The Queen at Sanaringham, making her first Christmas broadcast, 25 December 1952 (RCIN 2004814): PA/EMPICS

1953

Miss R. Essam of the Royal School of Needlework embroidering The Queen's Coronation robe, 11 Feb 1953 (RCIN 2002692): Copyright Reserved/The Royal Collection
Prince Charles's invitation to the Coronation; Joan Hassall, 1953 (collection of HRH

The Prince of Wales): photograph: The Royal Collection © 2006, HM Queen Elizabeth II

• The Sovereign's Orb with Cross, 1661 (RCIN 31718)

Saint Edward's Crown, 1661 (RCIN 31700)
The Sovereign's Sceptre with Cross, 1661 (RCIN 31712)

 Fireworks over Westminster and the Thames, on the evening of Coronation Day, 2 June 1953 (RCIN 2002708): Copyright Reserved/ The Roval Collection

 The Queen returning to Buckingham Palace wearing the Imperial State Crown and carrying the Orb and Sceptre, following the Coronation ceremony, 2 June 1953 (RCIN 2002719): Copyright Reserved/The Royal Collection

1954

• The Queen and Duke of Edinburgh en route to Parliament House, Brisbane, 10 March 1954 (RCIN 2999829): Copyright Reserved/ The Royal Collection

• Gold lamé and white lace one-shoulder dress: Norman Hartnell, 1953 (RCIN 200112)

 Diamond-set Garter Star, 1923 (RCIN 200147)
 The Queen in Garter Robes, November 1955 (RCIN 2999982): photograph by Cecil Beaton; photograph: The Royal Collection; © V&A Images/Victoria and Albert Museum

• Double-sided diamond-mounted Garter and Thistle Badge: cameo engraved by Edward Burch, .c.1810, reset 1829 and 1840 (RCIN 100032r)

1956

 A.L. Wilcox, *HMY Britannia arriving at Tower Pier, London, May 1954* (oil on canvas; RCIN 402053; collection of HRH The Duke of Edinburgh)

 The Royal Family on HMY Britannia, 1956 (RCIN 500782): Copyright Reserved/The Royal Collection

 Sir Hugh Casson, Corgis observing HMY Britannia, from an illustrated letter (pen and ink, and watercolour; Royal Collection)
 The Queen arriving at the House of Representatives, Lagos, 2 February 1956 (RCIN

2003058): Copyright Reserved/The Royal Collection

• Cream silk dress with gold embroidery: Norman Hartnell, 1956 (RCIN 200111)

1957

• The Queen's car in Lower Broadway, New York, October 1957 (RCIN 2003331): Topfoto • 'The Queen's Cup': Steuben crystal, glass designed by George Thompson, engraving designed by Bruce Moore, 1957 (RCIN 63175)

1958

• The Queen at her desk in Buckingham Palace, 25 January 1959. Topfoto

• One of The Queen's red boxes

1959

HRH The Duke of Edinburgh, *The Queen at the breakfast table in the Private Dining Room, Windsor Castle, c.*1960 (oil on canvas; RCIN 406980; collection of HRH The Duke of Edinburgh)

• The Queen with 'Sugar' at Frogmore, Windsor, May 1959: photograph by Studio Lisa, Camera Press London

• Marjorie Porter, 'Sugar', 1957 (coloured chalks; RCIN 451863)

• Sir Hugh Casson, *Conference (snoozing corgis)*, from an illustrated letter (pen and ink and watercolour; Royal Collection)

1960

The Queen with Prince Andrew, March 1960 (RCIN 2999909): photograph by Cecil Beaton; photograph: The Royal Collection; © V&A Images/Victoria and Albert Museum
C. Day-Lewis, 'Birthday Song for a Royal Child' (RCIN 1047141a)
Queen Mary's diamond 'Lover's Knot' brooch, late nineteenth century (RCIN 200142)
The Queen seated at Buckingham Palace, on the day of Princess Margaret's wedding, May 1960: photograph by Cecil Beaton; © V&A

Images/Victoria and Albert Museum • Turquoise silk and lace dress and jacket: Norman Hartnell, 1960 (RCIN 100041)

1961

 The Queen riding a richly decorated elephant in India, 1961: photograph by kind permission of Reginald Davis
 Princess Elizabeth and companions riding an

elephant at London Zoo, 1939 (RCIN 2002142): Copyright Reserved/The Royal Collection

• Carved and painted wooden model of an elephant, 1960 (RCIN 45970)

1962

Graham Sutherland, Design for Christ in Glory, 1954 (coloured chalk and bodycolour; RCIN 451887; collection of HRH The Duke of Edinburgh): Estate of Graham Sutherland
The Queen signing the Sentence of Consecration of Coventry Cathedral, 25 May 1962 (RCIN 2007621): photograph by Greenwood:
The Times, London, 26.05.1962

1963

• The Queen opening the New Zealand Parliament in Wellington, 18 February 1963: Archives New Zealand/Te Rua Mahara O Te Kāwanatanga Wellington Office

• Greenstone mere 'Budding Cloud' (RCIN 37065)

• Dress worn by The Queen at the opening of the New Zealand Parliament, February 1963: photograph by Joe Little

1964

 The Queen with Prince Edward and the infant Prince Andrew, May 1964 (RCIN 2999987): photograph by Cecil Beaton; photograph: The Royal Collection; © V&A Images/Victoria and Albert Museum

• Prince Edward's christening cake, 1964 (RCIN 2999828)

1965

• The Queen with Emperor Haile Selassie, February 1965 (RCIN 2003217): Copyright Reserved/ The Royal Collection

• Green silk gown: Norman Hartnell, 1965 (RCIN 200122)

• Gilt and white metal cross, 1969 (RCIN 37028)

1966

 The Queen's programme and programme cover for the World Cup, 30 July 1966 (RA PS/QEII/PS 12800.34): photograph: The Royal Collection; Copyright Reserved

• The Queen presenting the World Cup to Bobby Moore, Wembley, 30 July 1966 (RCIN 2999827): S&G/EMPICS/Alpha

1967

• The Queen reading her speech at the State Opening of Parliament, 1967 (RCIN 2007455): Copyright Reserved/The Royal Collection

• The Imperial State Crown, 1838 (RCIN31701)

• The Diamond Diadem, 1820 (RCIN 31702)

1968

The Queen dressed in her admiral's cloak, October 1968 (RCIN 2999826): photograph by Cecil Beaton; photograph: The Royal Collection;
@ V&A Images/Victoria and Albert Museum
Coins (dated 1971) struck by The Prince of Wales (2p), The Queen (1p), and The Duke of Edinburgh (2p), 1968 (RCIN 443906, 443909, 443915): Crown Copyright

• The Queen at the opening of the new Royal Mint at Llantrissant, with the Deputy Master of the Mint, Jack James, December 1968: picture courtesy of the Western Mail

1969

• Blue wax seal attached to The Prince of Wales's letters patent (RCIN 1122877a)

• The investiture coronet of The Prince of Wales: Louis Osman, 1969 (gold, diamonds, emeralds; RCIN 69058)

• The Queen and The Prince of Wales at the investiture of The Prince of Wales, Caernarvon Castle, July 1969: photograph by kind permission of Reginald Davis

1970

 Aerial view of HMY Britannia escorted into Brisbane Harbour, April 1970 (RCIN 2003899): Copyright Reserved/The Royal Collection

• The Queen in her Sitting Room at Buckingham Palace, 1970 (RCIN 2999825): photograph by Joan Williams, BBC

• The Queen in Thistle Robes before the Thistle Service in St Giles's Cathedral, July 1971: photograph by Denis Straughan; © The Scotsman Publications Limited

• Diamond-set Thistle Star, c.1820 (RCIN 200150)

• Double-sided diamond-mounted Garter and Thistle Badge: cameo engraved by Edward Burch, *c*.1810, reset 1829 and 1840 (RCIN 100032v)

1972

 The Queen with King Bhumibol, during the State Visit to Thailand, February 1972 (RCIN 2999824): Copyright Reserved/The Royal Collection

• White crepe shift dress with yellow beaded embroidery: Norman Hartnell, 1960 (RCIN 100039)

 The Queen and The Duke of Edinburgh entering the City of London during their Silver Wedding celebrations, 20 November 1972 (RCIN 2999848): Copyright Reserved/The Royal Collection

 Nest of silver boxes engraved with views of the royal residences: Gerald Benney, 1972 (RCIN 95749)

1973

The Queen at the Maundy Service at Westminster Abbey, 19 April 1973: photograph by kind permission of Reginald Davis
The Order of Service for the Maundy Service, Westminster Abbey, 19 April 1973 (RA PS/QEII/PS 12800.49): reproduced by kind permission of the Dean and Canons of Westminster Abbey; photograph © 2006, HM Queen Elizabeth II
Silver Maundy money, including a set of four

silver coins for 1973 (RCIN 443920): Crown Copyright

1974

Roy Miller, Highclere, with Joe Mercer up (wearing The Queen's colours), 1974 (oil on canvas; RCIN 401289): artist: Roy Miller SEA AAEA; photograph: The Royal Collection
The Queen in the winner's enclosure at Newmarket after Highclere had won the 1,000 Guineas, 1974: photograph by Alec Russell
The Queen's racing colours

1975

• The Order of Australia: Dame's badge, 1975 (RCIN 441549)

• The Order of Canada: Companion's badge, 1967 (RCIN 441545)

• The Queen's Service Order, New Zealand: Lady's Badge, 1975 (RCIN 441553)

1976

• The Queen at the Tercentenary Parade of the Royal Company of Archers at the Palace of Holyroodhouse, Edinburgh, 19 October 1976: photograph: The Royal Collection; reproduced by kind permission of The Royal Company of Archers

• *The Archer's cup*: glass engraved by Alison Geissler, 1976 (RCIN 29045)

1977

• The Queen at the Silver Jubilee Thanksgiving Service in St Paul's Cathedral, June 1977 (RCIN 2007275): Copyright Reserved/ The Royal Collection

• Sir Hugh Casson, *HMY Britannia at the Silver Jubilee Naval Review, Spithead, 1977* (watercolour; RCIN 450742)

• The Queen visiting Highbury Fields during the Silver Jubilee tour of North London, 6 July 1977 (RCIN 2007269): Copyright Reserved/The Royal Collection

 The Addresses of Her Majesty Queen Elizabeth II delivered at Westminster Hall and Guildhall on the occasion of her Silver Jubilee miniature book published Worket, Massachusetts, 1977; binding by S.M. Cockerell (RCIN 1058157)
 Silver Jubilee crown (RCIN 444004): Crown Copyright

1978

• The Queen with her first grandchild, Peter Phillips, April 1978 (RCIN 2999822): photograph by Snowdon, Camera Press London

1979

The Queen with the Amir of Bahrain (Shaikh Isa bin Sulman Al-Khalifa), February 1979: photograph by Anwar Hussein
Gold model of the welcome ceremony in Bahrain, with HMY Britannia, 1984 (RCIN 94125)

1980

 The Queen, Queen Elizabeth The Queen Mother and Princess Margaret, 1980: photograph by Norman Parkinson; Norman Parkinson Ltd/ Norman Parkinson Archive

1981

• The Queen with The Princess of Wales and her bridesmaids, in the Picture Gallery, Buckingham Palace, 29 July 1981: photograph by Patrick Lichfield, Camera Press London

• Order of Service, and Ceremonial, for the marriage ceremony of the Prince of Wales and Lady Diana Spencer, 29 July 1981: © 2006, HM Queen Elizabeth II

1982

• Family group following the Christening of Prince William, 4 August 1982: PA/EMPICS

1983

• The Queen presenting the Order of Merit to Mother Teresa of Calcutta, at the Rashtrapati Bhavan in New Delhi, 24 November 1983 (RCIN 2002815): PA

• The Order of Merit: Lady's Badge

• The Queen and The Duke of Edinburgh at Balmoral, 1981: Reproduced by kind permission of Balmoral Estate; Copyright Reserved/The Royal Collection

 Queen Victoria's Sitting Room, Balmoral Castle, 1983: Sir Geoffrey Shakerley; photograph by Geoffrey Shakerley

• James Roberts, *The Drawing Room, Balmoral Castle*, 1857 (watercolour and bodycolour; RCIN 919477)

• HRH The Prince of Wales, *The Dee Valley and Invercauld from Ballochbuie Forest*, 1988 (watercolour; collection of HRH The Prince of Wales): copyright A.G. Carrick

1984

The Queen and Duke of Edinburgh with King Hussein and Queen Noor, beside the Dead Sea during the State Visit to Jordan, March 1984: PA/EMPICS photographer Ron Bell
State Invitation letter from King Hussein of Jordan to The Queen, 17 August 1983: photograph © 2006, HM Queen Elizabeth II
Jordanian programme for the State Visit: photograph © 2006, HM Queen Elizabeth II
Jordanian programme for the State Visit: photograph © 2006, HM Queen Elizabeth II
Mother-of-pearl casket and bible, 1966 (RCIN 92131)

1985

• The Queen riding Burmese for the Birthday Parade, June 1985 (RCIN 2007076): Copyright Reserved/The Royal Collection

• Burmese's headcollar strap (RCIN 98010)

• Side-saddle used by The Queen when riding Burmese: Turner & Bridger, Epsom, 1969 (RCIN 93812)

 The Queen riding Burmese, with other members of the Royal Family, for the Birthday Parade, June 1978 (RCIN 2007292): Copyright Reserved/ The Royal Collection

• Plumed hat worn by The Queen for the Birthday Parade

 Sixtieth birthday portrait of The Queen, 1986 (RCIN 502021): photograph by HRH The Duke of York; HRH Prince Andrew/Camera Press

• Graham Rust, Design for a bookplate for The Queen, 1986 (pen and ink and wash; RCIN 452736)

• The Queen photographing The Duke of Edinburgh in China, October 1986 (RCIN 2002884): Copyright Reserved/The Royal Collection

• The Queen inspecting the terracotta warriors at Xian, 16 October 1986: photographer PETER BREGG/AP/EMPICS

1987

· Letters patent, with royal sign manual, granting the title of Princess Royal to The Princess Anne, 9 June 1987 (RA Warrants/ASPR): The Royal Archives; Crown Copyright material reproduced with the permission of the Crown Office of the House of Lords; photograph: © 2006, HM Queen Elizabeth II

1988

· Selection of nine Christmas cards, sent by The Queen and Duke of Edinburgh, 1985-2002 (RCIN 2999883, 2999877, 2999881, 2999879, 2999880, 2999882, 2999874, 2999878, 2999875): photograph Copyright Reserved/ The Royal Collection

• Sir Hugh Casson, Father Christmas with reindeer, from an illustrated letter (watercolour and pen and ink; Royal Collection)

1989

• Fragment of the Berlin Wall, demolished 1989 (RCIN 37064)

• The Queen and President Gorbachev of the USSR during his visit to Windsor Castle, April 1989: picture courtesy of Windsor & Eton Express. A Trinity Mirror title

• Notice sheet concerning President Gorbachev's visit, 7 April 1989: © 2006, HM Queen Elizabeth II

1990

• The Queen visiting the hot springs at Krisuvik, Iceland, 27 June 1990 (RCIN 2880511): Copyright Reserved/The Royal Collection • The Icelandic Government programme for the State Visit to Iceland, June 1990: photograph © 2006, HM Queen Elizabeth II

1991

• The Queen addressing a meeting of both Houses of Congress, 16 May 1991: photograph by Anwar Hussein

· 'Shakespeare' flower bowl, 1991: Steuben glass, designed by Jane Osborn-Smith (RCIN 95751) • Programme for the State Visit to Washington DC, May 1991: © 2006, HM Queen Elizabeth II

1992

• Ted Hughes, 'The Unicorn', 6 February 1992 (RCIN 1008643): poem © Estate of Ted Hughes; photograph: The Royal Collection • Stained glass window in the new Private Chapel, Windsor Castle, completed 1997: Joseph Nuttgens, to a design by The Duke of Edinburgh • The north-east corner of the Quadrangle, Windsor Castle ablaze, 20 November 1992: Tim Graham • The Queen with a fireman at Windsor Castle, 20 November 1992: photograph courtesy of the Royal Berkshire Fire and Rescue Service

1993

• The Queen at a garden party at Hillsborough Castle, Belfast, 11 June 1993: Pacemaker Press Intl. Belfast

1994

· Coloured lace ribbon and gilt medal commemorating the inauguration of the Channel Tunnel, 6 May 1994 (RCIN 63720, 446152) • The Queen and President Mitterand of France at the official opening of the Channel Tunnel, May 1994 (RCIN 2899999): PA/EMPICS photographer Tim Ockenden

1995

• The Queen with Queen Elizabeth The Queen Mother and Princess Margaret on the balcony of Buckingham Palace, on the fiftieth anniversary of VE Day, 8 May 1995: photograph by Stewart Mark, Camera Press London . The Royal Family with Winston Churchill on the

balcony of Buckingham Palace, VE Day, 8 May 1945 (RCIN 2999895): photograph by ILN, Camera Press London

1996

• The Queen and Nelson Mandela, President of South Africa, before the State Banquet at Buckingham Palace, July 1996: WPA Rota photograph by John Stillwell/PA/EMPICS · Programme for the State Banquet for President Mandela, 9 July 1996: © 2006, HM Queen Elizabeth II • Silk head scarf: S. Mackie, 1995 (RCIN 94158)

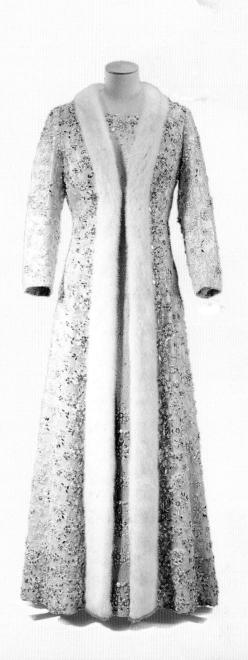

• The Queen and The Duke of Edinburgh outside Buckingham Palace among the tributes to Diana, Irincess of Wales, September 1997: photograph by Camera Press London

 The Queen and The Duke of Edinburgh, with members of the Royal Family, at the Thanksgiving Service for the Golden Wedding, Westminster Abbey, November 1997: PA/EMPICS photographer John Stillwell

 Glass martini jug with E and P overlaid in gold around neck (RCIN 95750)

1998

• Programme for the Reception for The Prince of Wales, 13 November 1998: © 2006, HM Queen Elizabeth II

• The Queen and The Prince of Wales at the reception for his fiftieth birthday at Buckingham Palace, 13 November 1998: photograph by Camera Press London

1999

 The Queen inspecting a model of the Millennium Dome during a visit to the Royal Institution of Chartered Surveyors in London, 29 July 1999.
 PA/EMPICS photographer Sean Dempsey
 The Queen at Greenwich after lighting the millennium flame, 31 December 1999.
 PA/EMPICS photographer Fiona Hanson

2000

 Queen Elizabeth The Queen Mother and The Queen on the balcony of Buckingham Palace on Queen Elizabeth's hundredth birthday, 4 August 2000 (RCIN 2999977): photograph by Jeff Moore. National Pictures

 Congratulatory telegram sent by The Queen to Queen Elizabeth on her hundredth birthday,
 4 August 2000 (RA QEQM/PRIV/CSP/FAM)
 EIIR finishing tool used in the Royal Bindery,
 Windsor (RCIN 98011)

• The Queen exchanging gifts at the Vatican with Pope John Paul II, October 2000: PA/EMPICS

2001

• The Queen at the Remembrance Day service, Whitehall, November 2001: PA/EMPICS photographer Toby Melville

Every effort has been made to contact copyright holders; any omissions are inadvertent and will be corrected in future editions if notification of the amended credit is sent to the Publisher in writing.

2002

Order of Service for the funeral of Princess Margaret, St George's Chapel, Windsor Castle, 15 February 2002: © 2006, HM Queen Elizabeth II
Order of Service for the funeral of Queen Elizabeth The Queen Mother, Westminster Abbey, 9 April 2002: © 2002 Dean and Chapter of Westminster; photograph: The Royal Collection

• Alexander Creswell, *The lying-in-state of Queen Elizabeth The Queen Mother in Westminster Hall, April 2002* (watercolour and bodycolour; RCIN 933811)

• The Queen in her Golden Jubilee Year, 2002: copyright www.royalimages.co.uk photographer Mark Lawrence

• The Queen's Family Order of King George VI (RCIN 200167)

• The Queen's Family Order of King George V (RCIN 200166)

• The Grand Duchess Vladimir's tiara, set with pearls, 1880s (RCIN 200145)

 Paul Sandby, South-east view of Windsor Castle from the Home Park, c.1765 (bodycolour on panel; RCIN 918986; acquired 1978)

• Porcelain basin, cover and stand with Stuart royal arms: Vincennes, *c*.1748-52 (RCIN 19605; basin and cover acquired 1964; stand acquired 1997)

• Gold caddinet: Anthony Nelme, 1688-9 (RCIN 31736; acquired 1975)

• French psalter, *c*.1520, with poem signed by Elizabeth I (RCIN 1051596; wedding present, 1947)

• John Hoskins, *Queen Henrietta Maria*, c.1632 (watercolour and bodycolour on vellum; RCIN 420891; acquired 1968)

• Queen Mary's patch box, c.1694 (gold, enamel, diamonds; RCIN 19133; acquired 1963)

 The Prince of Wales and The Queen at the opening of The Queen's Gallery, Buckingham Palace, May 2002: Copyright Reserved/The Royal Collection

2003

 The Queen and Prince William on the balcony at Buckingham Palace, June 2003: PA/EMPICS photographer Anwar Hussein/allaction.co.uk
 The Golden Jubilee equestrian monument to The Queen in Windsor Great Park, February 2006 (RCIN 2999819): photograph by HRH The Prince Philip, Duke of Edinburgh; Copyright Reserved/The Royal Collection

2004

 The Queen riding at Windsor with Zara Phillips and The Princess Royal, 10 April 2004 (RCIN 2999907): photograph by Eva Zielinska-Millar, The Royal Collection © 2006, HM Queen Elizabeth II

• The Queen riding at Ascot, June 1960 (RCIN 2006975): Copyright Reserved/The Royal Collection

2005

 The Queen in St George's Hall, Windsor Castle, at the reception following the Thanksgiving Service for the marriage of The Prince of Wales and The Duchess of Cornwall, 9 April 2005: photograph by permission of Hugo Burnand
 Order of Service for the St Paul's Cathedral Service of Remembrance London 2005,
 November 2005: reproduced by kind permission of the Dean of St Paul's Cathedral

2006

• Eightieth birthday portrait of HM The Queen, February 2006 (RCIN 2999843): photograph by Jane Bown; Jane Bown/Camera Press

Illustrations section

• Sir Hugh Casson, *The Selection Committee*, from an illustrated letter (pen and ink and watercolour; Royal Collection)

• Princess Elizabeth, Queen Mary and the Duchess of York at Balmoral, 1927 (RCIN 2999821): photograph by The Duke of York (later King George VI)

• Cream embroidered silk gown, 1950s?: Norman Hartnell (RCIN 200120)

• Pale blue faille dress embroidered with white china beads, 1951 (RCIN 100096)

• Embroidered silver tulle evening coat, edged with fur, 1970s: Norman Hartnell (RCIN 200130)

• White leather handbag, 1970: Launer